Memoirs of the Blind

Jacques Derrida

Memoirs of the Blind

The Self-Portrait and Other Ruins

Translated by
Pascale-Anne Brault and Michael Naas

The University of Chicago Press
Chicago and London

Jacques Derrida is Professor at the École des Hautes Études en Science Sociales in Paris.
He is the author of many works, including *The Truth in Painting* and *Of Spirit,* both
available from the University of Chicago Press.

The University of Chicago Press, Chicago 60637
The University of Chicago Press, Ltd., London
© 1993 by The University of Chicago
All rights reserved. Published 1993
Printed in the United States of America

02 01 00 99 98 97 96 95 94 93 5 4 3 2 1

ISBN (cloth): 0-226-14307-4
ISBN (paper): 0-226-14308-2

Originally published as *Mémoires d'aveugle: L'autoportrait
et autres ruines,* © Éditions de la Réunion des
musées nationaux, 1990.

Library of Congress Cataloging-in-Publication Data

Derrida, Jacques.
 [Mémoires d'aveugle. English]
 Memoirs of the blind : the self-portrait and other ruins / Jacques
Derrida ; translated by Pascale-Anne Brault and Michael Naas.
 p. cm.
 French ed. originally published on the occasion of an exhibition
held at the Louvre Museum, Paris, Oct. 26, 1990–Jan. 21, 1991.
 ISBN 0-226-14307-4. — ISBN 0-226-14308-2 (pbk.)
 1. Drawing—Philosophy. 2. Visual perception. 3. Blind in art.
4. Aesthetics. I. Musée du Louvre. II. Title.
NC703.D4713 1993
741'.01—dc20 92-27027
 CIP

This book is printed on acid-free paper.

Contents

Translators' Preface

The French edition of *Memoirs of the Blind* was first published on the occasion of an exhibition of the same name held at the Louvre Museum (Napoléon Hall) from October 26, 1990 to January 21, 1991. Organized by Derrida, *Memoirs of the Blind* was the first in a new series of exhibitions entitled *Parti Pris*—or "Taking Sides." In their introduction to Derrida's book, Françoise Viatte and Régis Michel, respectively head curator and curator of the Department of Graphic Arts at the Louvre, introduced this new series:

> The rule of the game is rather simple: to give the choice of a discourse and of the drawings that would justify it—drawings taken for the most part from the Louvre's collections—to personalities known for their critical abilities, however diverse these may be. The term *choice* would refer not to some personal predilection where the gratuitous flights of subjectivity would win out, but, rather, to a reasoned meditation on the demonstrative virtue of the work and its argumentative value. Naturally, the curators are closely associated with these exhibitions and offer to the person commissioned their knowledge of resources. But the freedom of the author remains sovereign and is acknowledged right from the start as an inviolable principle.
>
> One may certainly wonder about the reason for such a project. Why the discourse of the uninitiated in a domain where the specialist prevails? But to ask the question is already to give the answer. It is to admit that art has a hard time accommodating itself to monopolies, even if erudite; that even historians would agree that their exegesis stands to be enriched by other approaches, by another *gaze*. This first exhibition, which speaks of blind men and visionaries, is a sort of metaphor for this. Jacques Derrida's reflection goes to the heart of the phenomena of vision, from blindness to evidence. One will, no doubt, sometimes have to make an effort to read in registers unfamiliar to the neophyte. But if the game were not difficult, would it not be less playful? One can nonetheless take it for granted that at the end of the journey each one will have found their own light: what one learns here, in the literal as well as the figurative sense, are the ways of *opening eyes*.

But *Memoirs of the Blind* is more than simply a catalogue of an exhibition. First, the text presented along with the drawings and paintings at the exhibition was not the same as that found here. Second, a number of works that could not be exhibited have been included here: while the exhibition displayed some forty-four drawings and paintings, the book has seventy-one. Finally, the works are not presented in the same order in the book as in the exhibition. (To compare the two orderings, one may consult the list of illustrations where all the works exhibited are briefly described and their number in the exhibition given.)

Memoirs of the Blind is about, among many other things, the debt at the origin of all drawing. But there is also a debt—an inexhaustible one—at the origin of translation, and so the typical formulae of thanks are not simply obligatory expressions of modesty but exemplary inscriptions of an anxiety concerning a debt that can never be repaid. Thus we would first like to thank David Krell for bringing this project to our attention and for helping us at every step along the way. We are also indebted to Marie-Claire Pasquier of the University of Paris X, along with Philip Brown, Anna Vaughn, Bob Vallier, Lawrence Waxman, and Simone Zurawski of DePaul University, all of whom provided valuable comments and helped in various ways. Also, we would like to express our deep gratitude to Roger Kuin of York University in Canada, who generously made available to us his own unpublished translation of this text. His excellent work steered us clear of several potential pitfalls, while clarifying and improving our vision in many places.

And finally, our thanks to Jacques Derrida, for all his kindness, patience, and support, for seeing us through this—and for making it easier for us to believe.

To conclude, it may be worth noting that the series Taking Sides resumes in November 1992 with an exhibition organized by Peter Greenaway entitled *Le bruit des nuages* [The Sound of Clouds]: *Flying out of this World*. Now it just so happens that Greenaway is the writer and director of the film *The Draughtsman's Contract,* a film about the differences between drawing, painting, and sculpture, about allegory and ruin, about masks and funeral monuments, about strategies and debts, optics and blinds, about living statues and sounds represented in drawing. But above all it is about witnessing and testimony, about legacies and inheritances. And

these, it just so happens, are the very themes of *Memoirs of the Blind.*
Hence it may not be totally without interest to cite not only Mrs. Talmann's
words in *The Draughtsman's Contract* ("I have grown to believe that a
really intelligent man makes an indifferent painter, for painting requires a
certain blindness—a partial refusal to be aware of all the options") but its
closing scene—complete with murderous blows, burnt drawings, and the
floating corpse of the draughtsman.

> *Mr. Talmann:* We now have a contract with you, Mr. Neville, and under
> conditions of our choosing.
> *Mr. Noyes:* The contract concerning our present pleasure . . . has three
> conditions. . . . The contract's first condition, Mr. Neville, and there is
> no need to write it down for you will never see it, is to cancel your
> eyes.
> *Mr. Talmann:* Since we have now deprived you of your access to a living,
> this shirt on your back will be of no value to you.
> *Mr. Noyes:* It may well dangle from a scarecrow to frighten the crows.
> *Mr. Seymour:* Or be scattered about an estate as ambiguous evidence of
> an obscure allegory.
> *Poulencs:* And the third condition of your contract, concomitant to the
> other two . . . and legally binding . . . and efficiently undertaken . . .
> and for what is a man without property . . . and foresight . . . is your
> death.

Blindness, dispropriation, and the interruption of a lineage or filiation: the
cancellation of what makes representation possible, the difference between
the body proper and the supplement, the living body and the scarecrow,
and the ruination and death of all foresight, all representation, and all
legacies. Once again, these are Derrida's themes in *Memoirs of the Blind.*

Like a dream, then, of whispering clouds, one can almost hear this ob-
scure communication between past, present, and future, between Derrida
and Greenaway, between them and us, between all those "taking sides" on
the other side of vision—in the night. Derrida writes:

> A singular genealogy, a singular illustration, an illustration of oneself
> among all these illustrious blind men who keep each other in memory,
> who greet and recognize one another in the night.

Derrida in *Memoirs of the Blind* opens our eyes to this strange filiation,
to this odd sort of conversation or duel between different generations of

Taking Sides. For *Memoirs of the Blind* not only teaches us much about blindness, vision, and drawing—about philosophy and art—but leaves us another way to understand the legacy of drawing and vision, the legacy of representation, the legacy of legacy itself. It thus will have seen to it to interrupt the legacy of a monocular vision in order to lead us by the hand toward this other legacy that is passed down in darkness. Opening eyes, then, yes—but only in order to cancel them, and to recall that the draughtsman's contract always concerns a pleasure and a condition that are not only out of sight, but out of this world.

The French title *Mémoires d'aveugle* can be read as both "memoirs" and "memories" of the blind. Because the singular *aveugle* does not indicate gender, we have opted here and elsewhere for the plural "blind" in order to avoid both the gender specific "blind man" and the awkward "blind person." We have sometimes had to resort to "blind man," however, to translate the neutral *l'aveugle,* either because the context warranted it or because there simply were no better alternatives.

Memoirs of the Blind

I write without seeing. I came. I wanted to kiss your hand. . . . This is the first time I have ever written in the dark . . . not knowing whether I am indeed forming letters. Wherever there will be nothing, read that I love you.

—Diderot, Letter to Sophie Volland, June 10, 1759

— Do you believe this *[vous croyez]?** You'll observe that from the very beginning of this interview I've had problems following you. I remain skeptical . . .

— But skepticism is precisely what I've been talking to you about: the difference between believing and seeing, between believing one sees *[croire voir]* and seeing between, catching a glimpse *[entrevoir]*—or not. Before doubt ever becomes a system, *skepsis* has to do with the eyes. The word refers to a visual perception, to the observation, vigilance, and attention of the gaze *[regard]* during an examination. One is on the lookout, one reflects upon what one sees, reflects what one sees by delaying the moment of conclusion. Keeping *[gardant]* the thing in sight, one keeps on looking at it *[on la regarde]*. The judgment depends on the hypothesis. So as not to forget them along the way, so that everything be made clear, let me summarize: there would be *two hypotheses*.

— You seem to fear the monocular vision of things. Why not a single point of view? Why two hypotheses?

*This phrase, repeated on the next to the last line of the work, can be read in several ways, ranging from its everyday meaning, "Do you think so?," to the more literal, "Do you believe?," to the more incredulous, "Do you really believe this?" The phrase does not have a direct object, but we have given it one to indicate that it could be understood as a response to the epigraph or to the conversation in progress. —Trans.

— The two will cross paths, but without ever confirming each other, without the least bit of certainty, in a conjecture that is at once singular and general, the *hypothesis of sight,* and nothing less.

— A working hypothesis? A purely academic hypothesis?

— Both, no doubt, but no longer as *suppositions* (a *hypothesis,* as its name indicates, is supposed, presupposed). No longer beneath each step, therefore, as I set out, but always out ahead of me, as if sent out on reconnaissance: two antennae or two scouts to orient my wanderings, to guide me as I feel my way, in a speculation that ventures forth, simply in order to see, from one drawing to the next. I am not sure that I want to demonstrate this. Without trying too much to *verify,* my sights always set on convincing you, I will tell you a story and describe for you a point of view. Indeed the point of view will be my theme.

— Shall I just listen? Or observe? Silently watch you show me some drawings?

— Both, once again, or rather between the two. I'll have you observe that reading proceeds in no other way. It listens in watching. Here is a *first hypothesis:* the drawing is blind, if not the draftsman or draftswoman. As such, and in the moment proper to it, the operation of drawing would have something to do with blindness, would in some way regard blindness *[aveuglement].* In this *abocular* hypothesis (the word *aveugle* comes from *ab oculis:* not from or by but without the eyes), the following remains to be heard and understood: the blind man can be a seer, and he sometimes has the vocation of a visionary. Here is the *second hypothesis* then—an eye graft, the grafting of one point of view onto the other: a drawing of the *blind* is a drawing *of* the blind. Double genitive. There is no tautology here, only a destiny of the self-portrait. Every time a draftsman lets himself be fascinated by the blind, every time he makes the blind a *theme* of his drawing, he projects, dreams, or hallucinates a figure of a draftsman, or sometimes, more precisely, some draftswoman. Or more precisely still, he begins to *represent* a drawing potency *[puissance]* at work, the very act of drawing. He invents drawing. The *trait* is not then paralyzed in a tautology that folds the same onto the same.* On the contrary, it becomes prey to

*We have left the word *trait* for the most part untranslated to preserve its range of meanings from a trait or feature to a line, stroke, or mark. —Trans.

allegory, to this strange self-portrait of drawing given over to the speech and gaze of the other. The subtitle of all these scenes of the blind is thus: *the origin of drawing.* Or, if you prefer, *the thought of drawing,* a certain pensive pose, a *memory of the trait* that speculates, as in a dream, about its own possibility. Its potency always develops on the brink of blindness. Blindness pierces through right at that point and thereby gains *in potential, in potency:* the angle of a sight that is threatened *or* promised, lost *or* restored, given. There is in this gift a sort of *re-drawing,* a *with-drawing,* or *retreat [re-trait],* at once the interposition of a mirror, an impossible reappropriation or mourning, the intervention of a paradoxical Narcissus, sometimes lost *en abyme,* in short, a specular *folding* or *falling back [repli]*—and a supplementary *trait.** It is best to use the Italian name for the hypothesis of this withdrawal *[retrait]* in memory of itself as far as the eye can see: the *autoritratto* of drawing.

For this very reason, you will excuse me for beginning so very close to myself.

By accident, and sometimes on the brink of an accident, I find myself writing without seeing. Not with my eyes closed, to be sure, but open and disoriented in the night; or else during the day, my eyes fixed on *something else,* while looking elsewhere, in front of me, for example, when at the wheel: I then scribble with my right hand a few squiggly lines on a piece of paper attached to the dashboard or lying on the seat beside me. Sometimes, still without seeing, on the steering wheel itself. These notations—unreadable graffiti—are for memory; one would later think them to be a ciphered writing.

What happens when one writes without seeing? A hand of the blind ventures forth alone or disconnected, in a poorly delimited space; it feels its way, it gropes, it caresses as much as it inscribes, trusting in the memory of signs and supplementing sight. It is as if a lidless eye had opened at the tip of the fingers, as if one eye too many had just grown right next to the nail, a single eye, the eye of a cyclops or one-eyed man. This eye guides the tracing or outline *[tracé];* it is a miner's lamp at the point of writing, a curious and vigilant substitute, the prosthesis of a seer who is himself invisible. The image of the movement of these letters, of what this finger-eye inscribes, is thus sketched out within me. From the absolute withdrawal of an invisible center or command post, a secret power ensures from a

Retrait (here *re-trait*) has sometimes been left untranslated to maintain its relationship to *trait,* but has been for the most part translated as withdrawal, retreat, or redrawing. —Trans.

distance a kind of synergy. It coordinates the possibilities of seeing, touching, and moving. And of hearing and understanding, for these are already words of the blind that I draw in this way. One must always remember that the word, the vocable, is heard and understood, the sonorous phenomenon remaining invisible as such. Taking up time rather than space in us, it is addressed not only from the blind to the blind, like a code for the nonseeing, but speaks to us, in truth, all the time of the blindness that constitutes it. Language is spoken, it speaks to itself, which is to say, *from/ of blindness.* It always speaks to us *from/of the blindness* that constitutes it. But when, in addition, I write without seeing, during those exceptional experiences I just mentioned, in the night or with my eyes glued elsewhere, a schema already comes to life in my memory. At once virtual, potential, and dynamic, this graphic crosses all the borders separating the senses, its being-in-potential at once visual and auditory, motile and tactile. Later, its form will come to light like a developed photograph. But for now, at this very moment when I write, I see literally nothing of these letters.

As rare and theatrical as these experiences may be—I called them "accidental"—they nonetheless impose themselves as an exemplary *mise en scène.* The extraordinary brings us back to the ordinary and the everyday, back to the experience of the day itself, to what always guides writing through the night, *farther* or *no farther [plus loin]* than the seeable or the foreseeable. "*Plus loin*" can here mean either excess or lack. (No) more knowledge *[savoir],* (no) more power *[pouvoir]:* writing gives itself over rather to *anticipation.* To anticipate is to take the initiative, to be out in front, to take *(capere)* in advance *(ante).* Different than *precipitation,* which exposes the head *(prae-caput),* the head first and ahead of the rest, anticipation would have to do with the hand. The theme of the drawings of the blind is, before all else, the hand. For the hand ventures forth, it *precipitates,* rushes ahead, certainly, but this time *in place* of the head, as if to precede, prepare, and protect it. A safeguard, a guardrail. Anticipation guards against precipitation, it makes advances, puts the moves on space in order to be the first to take, in order to be forward in the movement of taking hold, making contact, or apprehending. Standing on his own two feet, a blind man explores by feeling out an area that he must recognize without yet cognizing it—and what he apprehends, what he has apprehensions about, in truth, is the precipice, the fall—his having already overstepped some fatal line, his hand either bare or armed (with a fingernail, a cane, or a pencil). If to draw a blind man is first of all to show hands, it is in order to draw attention to *what one draws with the help of*

that with which one draws, the body proper *[corps propre]* as an instrument, the drawer of the drawing, the hand of the handiwork, of the manipulations, of the maneuvers and manners, the play or work of the hand—drawing as *surgery*.* What does "with" mean in the expression "to draw with hands"? Almost all the drawings of the blind could be entitled "Drawing *with* Hand" [Dessin *avec* main], as one would say "Drawing *with (the) Hand*" [dessin *à la main*], for example, using the syntax of Chardin's *Self-Portrait with Eyeshade [L'autoportrait dit à l'abat-jour]*.

Look at Coypel's blind men. They all hold their hands out in front of them, their gesture oscillating in the void between prehending, apprehending, praying, and imploring.

— Imploring and deploring are also experiences of the eye. Are you going to speak to me of tears?

— Yes, later on, because they say something about the eye that no longer concerns or regards sight, unless they still reveal it while veiling it. But look again at Coypel's blind men. Like all blind men, they must *advance*, advance or commit themselves, that is, expose themselves, run through space as if running a risk. They are apprehensive about space, they apprehend it with their groping, wandering hands; they draw in this space in a way that is at once cautious and bold; they calculate, they count on the invisible. It would seem that most of these blind men do not lose themselves in absolute wandering. These blind *men*, notice, since the illustrious blind of our culture are almost always men, the "great blind men," as if women perhaps saw to it never to risk their sight. Indeed, the absence of "great blind women" will not be without consequence for our hypotheses.[1] These blind men explore—and seek to foresee there where they do

*Derrida is himself indulging in a certain *jeu de mains* by playing on the hand *[main]* in *manipulations, manoeuvres*, and *manières*, as well as in the word *"chirurgie"*—surgery—which comes from the Greek *kheir* (hand) and literally means the "work of the hands." —Trans.

1. This is not a third but a *supplementary* hypothesis, a supporting conjecture. It exceeds the other two only in order to return to and complete them. Always as *hypotheses of sight*. Sure there are blind women, but not many, and one speaks about them, it is true, but not very much. They are saints rather than heroes. There is Saint Lucille, the Sicilian saint of the fourth century. She had taken a vow of virginity. Because of her name, and because her persecutors were said to have blinded her, she is implored to heal the afflictions of sight. Her eyes are said to have been kept as relics in the church of San Giovanni Maggiore in Naples. There is also Saint Odile, blind and threatened with death by her father, baptized in secret by a bishop following the order of God, who then restored her sight. There are

not see, *no longer* see, or do *not yet* see. The space of the blind always conjugates these three tenses and times of memory. But simultaneously. For example, in the drawings done in preparation for *Christ's Healing of* **2, 3** *the Blind of Jericho,* Coypel's men do not seek anything in particular; they implore the other, the other hand, the helping or charitable hand, the hand of the other who promises them sight. They would like to follow the gaze of the other whom they do not see. They would like to foresee there where they do not yet see, in order either to avoid falling in the physical sense or else to recover from a spiritual fall. And so it is Jesus who is facing them and who holds out his hand, he whose ministry was initially to announce the "recovery of sight to the blind."[2] "Jesus said to [the blind man of Jericho], 'Receive your sight; your faith has saved you.' Immediately he regained his sight and followed him, glorifying God."[3] The master of truth is the one who sees and guides the other towards the spiritual light.

> Can a blind person guide a blind person? Will not both fall into a pit? A disciple is not above the teacher, but everyone who is fully qualified will be like the teacher. Why do you see the speck in your neighbor's eye, but do not notice the log in your own eye?[4]

A draftsman cannot but be attentive to the finger and the eye, especially to anything that *touches* upon the eye, to anything that lays a finger on it in order to let it finally see or let it be seen *[donner à voir].* Jesus sometimes heals the blind simply by touching, as if it were enough for him to draw the outline of the eyelids in space in order to restore sight.* Thus:

no doubt others, but neither the biblical nor the Greek culture confers upon women an exemplary role in these great, paradigmatic narratives of blindness. These narratives are dominated by the filiation father/son that we will see haunting so many drawings. And yet, the very fact that at the origin of drawing there should be the figure of a draftswoman, Butades for example, should shed light on rather than threaten our point of view.

*The phrase *rendre la vue* has been translated throughout as "to restore sight," though the reader should keep in mind that *rendre* means not only to restore but to repay, to give back, to return, to restitute. —Trans.

2. Luke 4:18. [All Biblical translations are from the *New Revised Standard Version: The New Oxford Annotated Bible* (New York: Oxford University Press, 1991). All translations of this and other texts have been slightly modified according to context for the sake of consistency.—Trans.]

3. Luke 18:42–43; see also John 9:1ff.; Mark 8:22ff.

4. Luke 6:39–42.

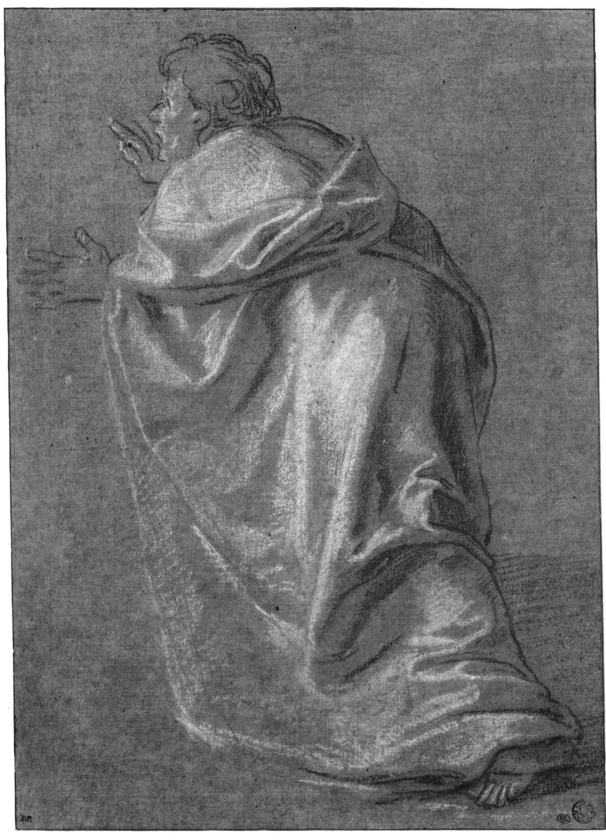

1. Antoine Coypel, *Study of the Blind,* Louvre Museum.

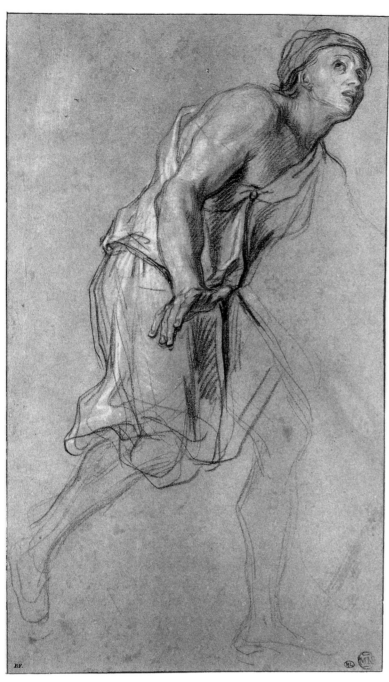

2. Antoine Coypel, *Study of the Blind,* Louvre Museum.

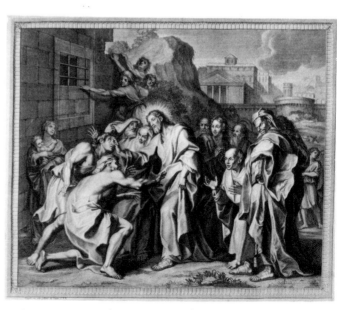

3. Antoine Trouvain, after Antoine Coypel, *Christ's Healing of the Blind of Jericho,* Bibliothèque Nationale.

As they were leaving Jericho, a large crowd followed [Jesus]. There were two blind men sitting by the roadside. When they heard that Jesus was passing by, they shouted, "Lord, have mercy on us, Son of David!" The crowd sternly ordered them to be quiet; but they shouted even more loudly, "Have mercy on us, Lord, Son of David!" Jesus stood still and called them, saying, "What do you want me to do for you?" They said to him, "Lord, let our eyes be opened." Moved with compassion, Jesus touched their eyes. Immediately they regained their sight and followed him.[5]

As with touching, the laying on of hands orients the drawing. One must always recall the other hand or the hand of the other. La Fage arranges the hands in such a way that at the moment when Christ's right index finger shows, *by touching it,* the blind man's left eye, the blind man touches Christ's arm with his right hand, as if to accompany its movement, and, first of all, to reassure himself of it in a gesture of prayer, imploration, or gratitude. Both of the left hands remain drawn back *[en retrait].* Compare them to the left hands in Ribot's drawing: Christ's is open and turned back towards him, while the blind man's is opened upwards (begging, praying, supplicating, imploring, praising). In his right hand, between his legs, he still holds firmly onto his cane, the cane that—and he is not yet ready to forget it—was his saving eye, his emergency eye, one might even say his optical prosthesis, more precious than his own pupils, than the apples of his eyes *[la prunelle de ses yeux].* As for Federico Zuccaro, he peoples the space of healing with a whole crowd, between an enormous column (around which a man with fleshy buttocks wraps himself) and the long staff of the kneeling blind man. The man's hands are joined this time, his instrument extending far above his head.

Lucas Van Leyde's blind man is less passive. He himself, with his own hand, will have pointed out his eyes; he will have shown his own blindness to Christ. Doing the presenting himself, as if a blind man were doing his own portrait—the self-portrait of a blind man telling his own story in the first person—he will have indicated, localized, and circumscribed his blindness with his right hand turned back towards his face, his index finger pointing towards his right eye. Turned towards the eye, the finger's gesture shows but does not touch the body proper. It draws or forms, at a suitable or respectful distance, a sort of obscure self-showing, nocturnal yet

5. Matt. 20:29–34; see Mark 10:46–53; Luke 18:35–43.

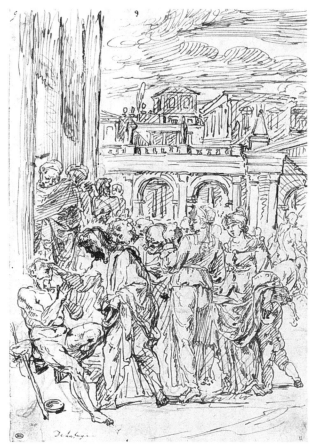

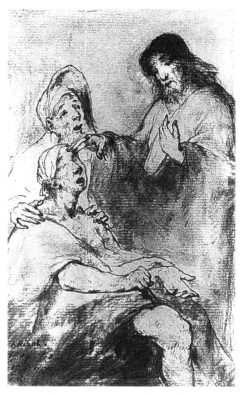

4. Raymond La Fage, *Christ Healing a Blind Man,* Louvre Museum.

5. Théodule Ribot, *Christ Healing a Blind Man,* Louvre Museum, Orsay Museum Collection.

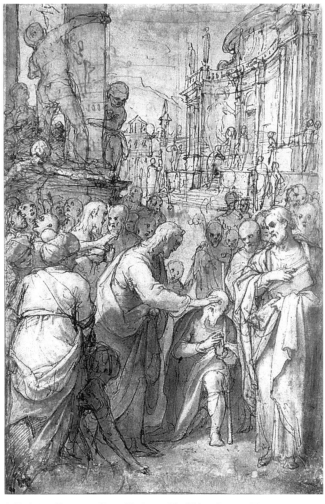

6. Federico Zuccaro, *Christ Healing a Blind Man,* Louvre Museum.

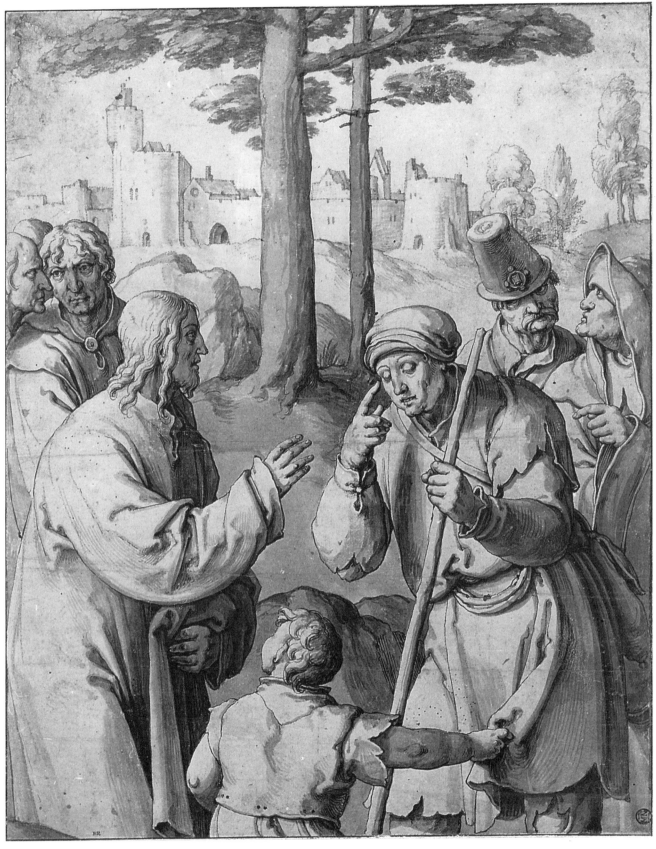

7. After Lucas Van Leyde, *Christ Healing a Blind Man,* Louvre Museum.

assured. A strange flexion of the arm or reflection of the fold. A silent auto-affection, a return to oneself, a sort of soul-searching or self-relation without sight or contact. It is as if the blind man were referring to himself with his arm folded back, there where a blind Narcissus, inventing a mirror without image, lets it be seen that he does not see. He shows himself, he shows up, but to the other. He shows himself with his finger *as* blind. And so there he is, guiding the hand of the Savior as if the other did not yet see the eye to be healed. The stricken man thus shows by waiting, imploring, and praying. He draws, draws in the space of a promise already received. In showing, he *does [fait]* something. No more than any drawing, the movement of the right hand is not content with simply pointing out, describing, or stating the truth of what is. It neither represents nor simply presents; it acts. As for the left hand, it holds firmly onto a long stick pressed against the right leg. This hardwood assistant stands curiously between him and the child, his son perhaps, in any case his guide—yet another assistant, but this time a living one, because one sees him from behind holding onto the blind man by a fold in his garment.

The play of fingers can be easily figured out. While the woman behind the stricken man points her left index finger in the same direction as the blind man's right index finger, as if to show the blindness of the other whose self-showing she nonetheless takes part in, the young boy orients the index finger of his right hand, the same hand as the blind man, in the opposite direction, not in order to show, this time, but to touch, to hold onto and hold up. Jesus' right hand is held out, but still at a distance; it sketches out or initiates a gesture to accompany—*like the woman facing him*—the right hand of the blind man: a mirror effect, around what we have called the mirror without image. The Savior's left hand, meanwhile, is busy on his stomach; like the child's hand, it is busy about the folds of a garment, this time his own, busy holding onto them, holding them up or holding them back, at what would seem to be the child's eye-level.

Sin, fault, or error—the fall also means that blindness *violates* what can here be called Nature. It is an accident that interrupts the regular course of things or transgresses natural laws. It sometimes leads one to think that the affliction affects both Nature and a nature of the will, the will to know [*savoir*] as the will to see [*voir*]. A bad will—an unwillingness—would have driven man to close his eyes. The blind do not want to know, or rather, would like not to know: that is to say, not to see. *Idein, eidos, idea:* the whole history, the whole semantics of the European *idea,* in its Greek genealogy, as we know—as we see—relates seeing to knowing. Look at

the allegory of *Error,* Coypel's blindfolded man. *Naturally* his eyes *would* 8, 9
be able to see. But they are *blindfolded [bandés]* (by a handkerchief, scarf,
cloth, or veil, a textile, in any case, that one fits over the eyes and ties
behind the head). Erect and blindfolded *[bandés],** not naturally but by
the hand of the other, or by his own hand, obeying a law that is not natural
or physical since the knot behind the head remains within a hand's reach
of the subject who could undo it: it is as if the subject of the error had
consented to having got it up, over his eyes, as if he got off *[jouissait]* on
his suffering and his wandering, as if he chose it, at the risk of a fall, as if
he were playing at seeking the other during a sublime and deadly game of
blind man's buff. His will is at stake, and he goes willingly; he is the one
who has been "touched," who stands erect and blindfolded. What does
Descartes, this thinker of the eye who one day analyzed his own inclination
"to like" "dubious characters" or "squinters," say about error? For the
author of the *Optics,* who also dreamed of making eyeglasses and of re-
storing sight to the blind, error is first of all a belief, or rather, an *opinion:*
consisting in acquiescing, in saying yes, in *opining* too early, this fault of
judgment and not of perception betrays the excess of infinite will over
finite understanding. I am in error, I deceive *myself,* because, being able
to exercise my will infinitely and in an instant, I can will to move myself
beyond perception, can will *[vouloir]* beyond sight *[voir].*

Am I in turn deceiving myself? Am I the victim of a hallucination when
I believe that I see, through this *Error* of Coypel, the figure of a draftsman
at work? I will explain myself later.

In any case, this *Error* of a man standing *alone, curious, anxious* to see
and to touch, his hands restless, given over from head to toe to sketching
out as much as to skipping out, bears no resemblance, as far as I can see,
even though this too has to do with an adventure of knowledge, to those
prisoners chained to opinion in the cave of the *Republic.* The Platonic
speleology itself develops, let us not forget it, an "image" of all possible
blindnesses, an "icon," as Plato often says, a word that is also translated as
allegory. Still blind to the idea of the things themselves, whose shadows
they contemplate as they are projected by the fire onto the wall in front of
them, these prisoners have been chained since childhood, "their legs and
necks in bonds so that they are fixed, seeing only in front of them, unable
because of the bond to turn their heads all the way around."[6] A conversion

Bandé means both blindfolded and sexually erect or hard. —Trans.
6. Plato, *The Republic,* 514a, trans. Allan Bloom (New York: Basic Books, 1968).

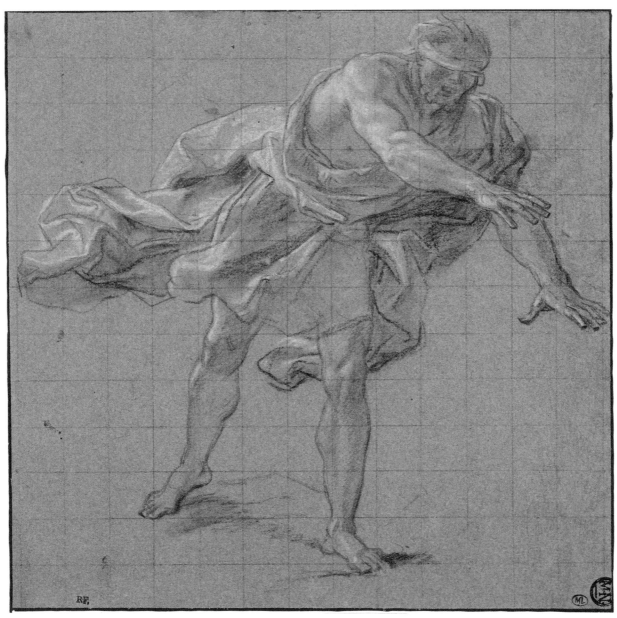

8. Antoine Coypel, *The Error*, Louvre Museum.

9. Louis Desplaces, after Antoine Coypel, *Truth Unveiled by Time*, Bibliothèque Nationale.

will free them from the phenomenal prison of the visible world. But before this dazzling ascent, an *anabasis* that is also an *anamnesis,* before this passion of memory that, at the risk of another blindness, will turn the soul's gaze towards the "intelligible place," these prisoners suffer from sight, to be sure, and they will suffer again, because "there are two kinds of disturbances of the eyes, stemming from two sources—when they have been transferred from light to darkness and when they have been transferred from darkness to light."[7] But Plato represents them as motionless. Never do they stretch out their hands towards the shadow *(skia)* or the light *(phôs),* towards the silhouettes or images that are drawn on the wall. Unlike Coypel's solitary man, they do not venture out with outstretched hands in the direction of this *skia-* or *photo-*graphy, their sights set on this shadow- or light-writing. They converse, they speak of memory. Plato imagines them seated, chained, able to address one another, to "dialectize," to lose themselves in the echoing of voices.

Before arbitrarily interrupting this infinitely echoing discourse, let us note for the sake of memory that, just before or above this, at the moment of descending, of guiding us into the cave, Plato had sketched out several analogies. Among them, a genealogy relates the sensible sun, the cause of sight and the image of the eye—for the sun resembles the eye, the most "helioform" of all sense organs[8]—to the intelligible sun, that is, to the Good, just as the son is related to the father who has begotten him in his own likeness.[9] The *anamnesis* of blindings, so many dazzlements *en abyme,*

7. Ibid., 517b–518a. What else does Socrates say—Socrates, whom Nietzsche will have nicknamed the "Cyclops eye"? [*The Birth of Tragedy,* section 14.] In the *Phaedo,* he cautiously proposes, then pretends to take back, an analogy (a trope, a *tropos,* a rhetorical turn) in order to explain this kind of conversion that turns one away from direct intuition or even turns the gaze toward the invisible: just as the fear of blindness might lead one to look at a dazzling star in an indirect way (for example, by turning to its reflection in water), so it is necessary to take refuge in the "*logoi*" in order not simply to see (σκοπεῖν) the "truth of the things that are" (τῶν ὄντων τὴν ἀλήθειαν), but in order to see this truth in the invisible forms that the *logoi* in fact are (ideas, words, discourses, reasons, calculations): ". . . since I had given up investigating the things that are (τὰ ὄντα σκοπῶν), I decided that I must be careful not to suffer the misfortune that happens to people who look at the sun and watch it during an eclipse. For some of them ruin their eyes unless they look at its image in water or something of the sort. I thought of that danger, and I was afraid my soul would be blinded if I looked at things with my eyes and tried to grasp them with any of my senses. So I thought I must have recourse to *logoi* (εἰς τοὺς λόγους) and examine in them the truth of the things that are. Now perhaps my metaphor *(tropos)* is not quite accurate . . ." (*Phaedo,* 99d–e, trans. Harold North Fowler [Loeb Classical Library, 1982]).

8. "ἡλιοειδέστατόν γε οἶμαι τῶν περὶ τὰς αἰσθήσεις ὀργάνων" (*Republic,* 508b).

9. ". . . φάναι με λέγειν τὸν τοῦ ἀγαθοῦ ἔκγονον, ὃν τἀγαθὸν ἐγέννησεν ἀνάλογον ἑαυτῷ . . ." (*Republic,* 508c).

can itself be followed, like this story, from the father to the son. And the absolute Good, the intelligible father who begets being as well as the visibility of being (the *eidos* figures an outline of intelligible visibility), remains as invisible as the condition of sight—as *visibility* itself—can be. Regarding the Good, its descent is peopled with sons born blind, with little suns, so many pupils from which one sees only on the condition of not seeing whence one sees. We are here in the logic of the little sun placed *en abyme,* about which Ponge asks at the heart of his long poem, *The Sun Placed en Abyme:* "Why has the French language, in order to designate the star of the day, chosen the verbal form derived from the diminutive *soliculus?*"

Let us recall that, in the case of the blind man, hearing goes *farther* than the hand, which goes *farther* than the eye. The hand has an ear for preventing the fall, that is, the *casus,* the accident; it thus commemorates the possibility of the accident, keeps it in memory. A hand is, here, the very memory of the accident. But for the one who sees, visual anticipation takes over for the hand in order to go even farther—indeed much farther. What does "farther" mean, and farther than the far-away itself? Taking it in, into its sights, the eye takes in more and better than the hand. To take—here a figure—is to be taken figuratively. The ear would carry still farther if the tropes of this rhetorical supplementarity did not always lead us farther—and always too far *[trop loin].* Indeed, it is about these tropes, about this *troppo,* this too-much of sight at the heart of blindness itself, that I would like to speak.

And so on the night of July 16th of last year, without turning on the light, barely awake, still passive but careful not to chase away an interrupted dream, I felt around with a groping hand beside my bed for a pencil, then a notebook. Upon awakening, I deciphered this, among other things: ". . . duel of these blind men at each other's throats, one of the old men turning away in order to come after me, to take me to task—me, poor passerby that I am. He harasses me, blackmails me, then I fall with him to the ground, and he grabs me again with such agility that I end up suspecting him of seeing with at least one eye half open and staring, like a cyclops (one-eyed or squinting, I no longer know); he restrains me with one hold after another and ends up using the weapon against which I am defenseless, a threat against my sons *[fils].* . . ."

I will offer no immediate interpretation of a dream so overdetermined by elders *[vieux]* and eyes *[yeux],* by all these duels. For many reasons. The idiomatic threads *[fils]* of my dream are, for me, neither clear nor countable—far from it—and since I have neither the desire nor the space

to expose here those that I might follow in a labyrinth, I will be content with naming a few of the paradigms, that is, a few of these commonplaces of our culture that often make us plunge headlong, by an excess of anticipation, into a misguided or seduced reading. This dream remains mine; it regards nobody else. What I will say of it here by way of figure, a parable on a parable, will thus come from what I earlier called precipitation. And while insinuating throughout an oblique or distracted reading of Bataille's narrative,[10] my *story of the eye* also indicates—in its recess or hollow—the necessity of an anthropology or cultural ophthalmo-pathology (a few statistics: why so many blind people in Greece, in biblical times, and in the past few centuries? How did one become blind? How was blindness treated, compensated for, or supplemented? What was the place of the blind in the family and in society? Were there really more blind men than women? etc.).

Oedipus has become tiresome, a bit worn-out; we have grown old with him. Even more so with Tiresias, the blind soothsayer or seer who leaps over generations and across sexual differences. Tiresias goes blind for having seen what must not be seen, the coupling of two snakes, or perhaps the nakedness of Athena, or perhaps even the Gorgon in the eyes of the goddess with the penetrating gaze *(oxyderkēs).*[11] He then predicts to Narcissus that he will go on living as long as he does not see himself, and to Pentheus that he will lose his life for having *seen* the sacred rites of Dionysus, or for having *let* himself *be seen* as a boar by the Bacchants. No,

10. It would be necessary to cite the entirety of *Histoire de l'oeil [Story of the Eye]*, especially the final *Réminiscences [Coincidences]*, the story of the photographs of *ruins*. ("But then one day I was looking through an American magazine, and I chanced upon two astonishing photographs: the first was a street in the practically unknown village from which my family comes; the second, the nearby ruins of a medieval fortified castle on a crag in the mountain. I promptly recalled an episode in my life connected to these ruins.") All these *Réminiscences* unfold within this photograph of ruins (the story of the "white ghost," the "church scene, particularly the plucking of an eye," "the association of the eye and the egg," of "testicules" and of the "eye globe") in order to inscribe a filiation. This filiation leads the author of these autobiographical reminiscences back to blindness as if to his paternal origin: "I was born of a syphillitic father (tabetic). He became blind (he was already blind when he conceived me) and, when I was two or three years old, the same disease paralyzed him . . . at night, his pupils were lost, rolled up beneath his eyelids; and this usually happened also when he pissed. He had huge, wide-open eyes, in the middle of an emaciated face, shaped like an eagle's beak" (Georges Bataille, *The Story of the Eye,* trans. Joachim Neugroschel [New York: Urizen Books, 1977], 102ff). Concerning this narrative, see Roland Barthes, "La métaphore de l'œil," *Critique* (August–September 1963): 195–96.

11. See Nicole Loraux, *Les expériences de Tirésias: Le féminin et l'homme grec* (Paris, 1989), esp. chapter 12, "Ce que vit Tirésias."

the memory of Tiresias is still too close to Oedipus. Mythology or not, when it comes to asking about the host of our great blind men, the West has other resources; it draws upon the reserves of a Greek memory that is an-Oedipean, pre- or extra-Oedipean, and it draws, above all, from the crypts or the apocrypha of a Biblical memory.

There are as many blind men in the Old Testament as in the New. And the relationship between the two testaments often represents a *sharing of vision* and a *difference in viewpoint [partage de la vue]*—as well as a partitioning of light. It is always the other who did not yet see. It is always the other who saw with an eye that was too natural, too carnal, too external, which is to say, too *literal*. Blindness of the letter and by the letter. Here is a symbol: the blindfolded synagogue.[12] The Pharisees, these men of letters, are, when you come right down to it, blind. They see nothing because they look outside, only at the outside. They must be converted to interiority, their eyes turned toward the inside; and a fascination must first be denounced, the body and exteriority of the letter reproached:

> Woe to you, scribes and Pharisees, hypocrites! For you cross sea and land to make a single convert, and you make the new convert twice as much a child of hell as yourselves. Woe to you, blind guides *[hodēgoi typhloi, duces caeci]*. . . . You blind fools *[mōroi kai typhloi, stulti et caeci]!* . . . You blind Pharisee! First clean the inside of the cup, so that the outside also may become clean.[13]

Earlier, Christ had recalled the prophecy of Isaiah: ". . . you will indeed look, but never perceive . . . they have shut their eyes; so that they might not look with their eyes. . . ."[14] The Jews would not have seen the truth: for example, that Christ, by applying to the eyes a mixture of mud and his own saliva, had been able to heal a man blind from birth.[15] This man surely

12. Concerning what he calls "an insurmountable gap . . . between a pagan civilization and a Christian one," Panofsky notes, ". . . on the one hand the Synagogue was represented as blind and associated with Night, Death, the devil, and impure animals; and on the other hand the Jewish prophets were considered as inspired by the Holy Ghost, and the personages of the Old Testament were venerated as the ancestors of Christ," (*Studies in Iconology, Humanistic Themes in the Art of the Renaissance* [New York: Harper & Row, 1972], 27, n. 26). Panofsky notes further on: "the blindfolded Synagogue (often described by the phrase *Vetus testamentum velatum, novum testamentum revelatum*) was commonly connected with the verse of Jeremiah: 'The crown is fallen from our heads, woe unto us that we have sinned, for this our heart is faint, for these things our eyes are dim' (Lam. 5:16–17)" (111).

13. Matt. 23:15–17ff., 26. 15. Mark 8:22; John 9:6.
14. Matt. 13:14–15ff.

10. Jacques-Louis David, *Homer Singing His Poems,* Louvre Museum.

had not sinned, nor had his parents, but it was necessary that he bear witness to God's works through his restored sight. By a singular vocation, the blind man becomes a witness; he must attest to the truth or the divine light. He is an archivist of visibility—like the draftsman, in short, whose responsibility he shares. This is one of the reasons why a draftsman is always *interested* by the blind: they are his very interest, for he is an interested party, which is to say, he is engaged and works *among them.* He belongs to their society, taking up in turn the figures of the seeing blind man, the visionary blind man, the healer or the sacrificer—by which I mean someone who takes away sight in order finally to show or allow seeing and to bear witness to the light.

Another witness, John, recalls that the truth and the light *(phōs)* come through Christ. The Jews dispelled this light because they "did not believe" that the healed blind man "had been blind. . . ." [16] The Gospels can be read as an *anamnesis* of blindness: the word that is sent, the word of *judgment* or *salvation,* the good news, always *happens* or *comes to blindness.* The advent or coming takes place according to the story of the eye; it draws this internal division of sight and viewpoint:

> Jesus said, "I came into this world for judgment so that those who do not see may see, and those who do see may become blind." Some of the Pharisees near him heard this and said to him, "Surely we are not blind, are we?" Jesus said to them, "If you were blind, you would not have sin. But now that you say, 'We see,' your sin remains." [17]

The blind men in my dream were ancestors, or rather, fathers, perhaps even grandfathers—in any case, old men. And there were several of them, at least two. I had jotted down "duel" during the night. So let us forget Oedipus for the moment, the two Oedipuses. Let us forget the Oedipus of "the great Homer," of the "harmonious blind man," an Oedipus who **10** does not, it must be underscored, gouge out his eyes.[18] But let us also forget Sophocles' Oedipus, the Oedipus of the "myth" and of the "complex," the enlightened blind man who draws in space with his staff, who mixes or jumps generations on two, three, or four feet. There are at least

16. John 9:18.
17. John 9:39–41.
18. These are the last words of *L'aveugle [The Blind Man],* the long poem written by Chénier in the style of Homer, in harmony with the song of the "harmonious blind man" who seems to sign his work, since his name is pronounced only at the very end. The last

three generations in my dream of the duel, of the dual *[duel]* and of dolor, of mourning *[deuil]*, of elders and eyes: the white figure of the ancestors, then my own generation, in place of the son, but a son who is already a father since his own sons are in turn threatened. And these generations jump; they jump over each other, and jump one another in order to take each other to task. But I am headed rather toward the testament. Specifically, toward the stories of legacy or delegation *on the inside, as en abyme,* of what is called the neo- or the paleo-testamentary. A testamentary scene always presupposes—along with the supplement of a generation—at least a third party who sees, the mediation of a lucid witness. By means of a story or a signature, this witness attests that he has clearly seen, thereby authenticating the act of memory and the last wish. In what way would blindness concern or—if one may say this—regard this family scene? And why is the third, this witness who authenticates the testament, himself also able to intervene in the scene, to trick or to play with blindness? Eli, Isaac, Tobit—all these old blind men of the Old Testament—are always in want of sons. They suffer through their sons, always waiting for them, sometimes to be tragically disappointed or deceived, but sometimes also to receive from them the sign of salvation or healing. At the time of my dream, I did not know the story of Eli, the mourning of him who, having already lost his eyes, loses or laments his two sons at once. And who dies as a result, thus losing his life after his sight—and after his sons. God had already announced to him that Hophni and Phinehas would die on the same day for having never respected the sacrifices to Yahweh. Like the old prophet Ahijah, to whom Jeroboam's wife tried to pass herself off as another woman,[19] the high priest Eli, ninety-eight years old, already no longer sees when the messenger announces to him—and this is a single event— the conjunction of the worst, the carrying off of both his sons *and* the ark. This is the moment of the fall: for the blind are beings of the fall, the manifestation always of that which threatens erection or the upright position (Samson, Saint Paul, Polyphemus, etc.). For at these terrible words, Eli falls over backward:

word thus converges with the proper name of the blessed blind man, "loved by the gods," who, let us no longer forget it, is invited within the "walls" of an "island": "Come within our walls, come live on our island; / Come, eloquent prophet, harmonious blind man. / Drinker of nectar, disciple loved by the gods; / Every five years, games will make holy and prosperous / The day we welcomed the great HOMER" (Paris: Pléiade, 1958).

19. Kings 14:6.

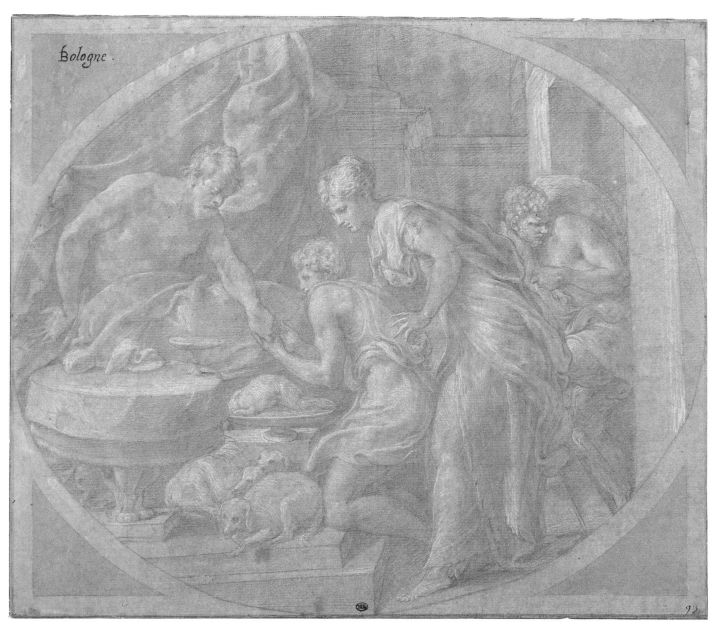

11. Francesco Primaticcio, *Isaac Blessing Jacob,* Louvre Museum.

". . . Israel has fled before the Philistines, and there has also been a great slaughter among the troops; your two sons also, Hophni and Phinehas, are dead, and the ark of God has been captured." When he mentioned the ark of God, Eli fell over backward from his seat by the side of the gate; and his neck was broken and he died. . . .[20]

If I have only recently discovered this double dolor or mourning of Eli (to be distinguished, if only by a bit, from Elijah, or Eliah, which turns out to be one of my first names), I must have read and then forgotten, at the time of my dream of elders and eyes, the plights of Isaac and Tobit.

These two fathers, these two old blind men, seem to be opposed in every way, trait for trait. One loses his sight with age, as if through normal wear and tear:

When Isaac was old and his eyes were dim so that he could not see, he called his elder son Esau and said to him, "My son"; and he answered, "Here I am." He said, "See, I am old; I do not know the day of my death."[21]

Moreover, the story of the ruse is related in *the third person*—the ruse by which Isaac's wife Rebecca takes advantage of her husband's blindness in order to substitute one son for another, that is, Jacob, the favorite younger son, for Esau, at the moment of the testamentary blessing. A nagging and interminable question: how does one sacrifice a son? A son who is always unique, always an only son *[un fils unique]?* Isaac knew a thing or two about this. His father had "looked up" twice at the decisive moment when he had to sacrifice him and then spare him by substituting a ram.[22] How does one choose between two sons? This is, twice multiplied, the same question, the unique question of the unique. How does one choose between two brothers? Between two twins, in sum, since Jacob was Esau's twin, even though he was born after him and his brother had sold him his birthright (he "despised his birthright").[23] Is this not more difficult than choosing between the pupils of one's own two eyes, between the two apples of one's eyes, which can at least supplement each other? To sacrifice a son is at least as cruel as giving up one's own sight. The son here represents the light of vision; that is what Tobit, in short, says to his son.

20. 1 Sam. 4:15–18.
21. Gen. 27:1–2ff.
22. Gen. 22:4, 13.
23. Gen. 25:34.

23

By contrast, then, in the book that bears his name and in the course of a narration that passes from one mouth to another, Tobit himself narrates at first, narrates *in the first person, narrates himself* by telling the story of his own blindness. Depicting himself, relating to himself, he relates a blindness whose advent was, in his case, not natural. He interprets it, in truth, as an obscure punishment. Another point of contrast is that he recovers from his blindness eight years later at the hands of his son Tobias. One will recall that the orphan Tobit had married Anna. He liked to bury the dead of his community (my father too liked to do this, and did so for decades in Algiers), sometimes secretly, fearing King Sennacherib (who was himself, in fact, killed by his own two sons). Tobit is stricken by blindness after having wept . . .

— I'll have you observe that you have already promised to speak of tears or veiled eyes, remember . . .

— I haven't forgotten. Tobit shed tears, then buried one of his own people who had been strangled and abandoned in the market place. He narrates, and it is once again a story of mourning:

> . . . I remembered the prophecy of Amos, how he said against Bethel, "Your festivals shall be turned into mourning, and all your songs into lamentation." And I wept. When the sun had set, I went and dug a grave and buried him. And my neighbors laughed and said, "Is he still not afraid? He has already been hunted down to be put to death for doing this, and he ran away; yet here he is again burying the dead!" That same night I washed myself and went into my courtyard and slept by the wall of the courtyard; and my face was uncovered because of the heat. I did not know that there were sparrows on the wall; their fresh droppings fell into my eyes and produced white films. I went to physicians to be healed, but the more they treated me with ointments the more my vision was obscured by the white films, until I became completely blind.[24]

Tobit's son Tobias restores his sight, as we know, by spreading fish gall on his father's eyes, following the advice of the angel Raphael: "'I know that **12**

24. Deuterocanonical Books, Tobit 2:6–10. This book was first part of the *Apocrypha* but was later recognized as part of the canon by the Council of Trent in 1546. Except for the titles of the drawings—which follow a tradition (Tobie)—we keep to the spelling of Tobit's name chosen by this Pléiade edition. [The *New Revised Standard Version* of the New Oxford Annotated Bible has adopted this same spelling. —Trans.]

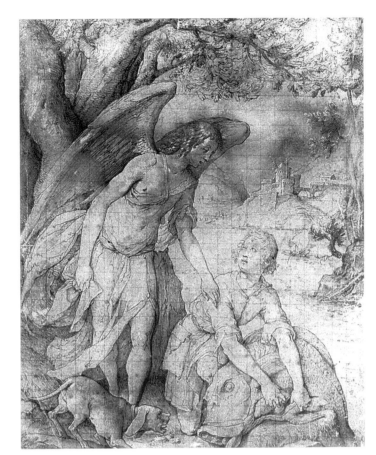

12. Jacopo Ligozzi, *Tobias and the Angel,* Louvre Museum.

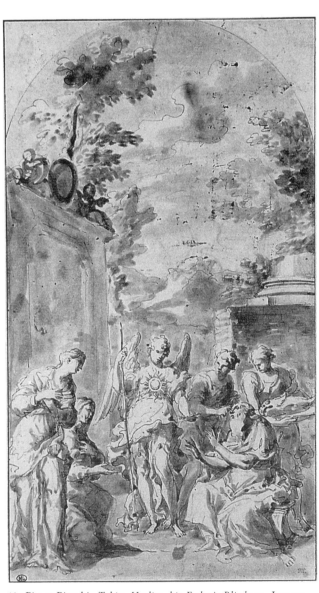

13. Pietro Bianchi, *Tobias Healing his Father's Blindness,* Louvre Museum.

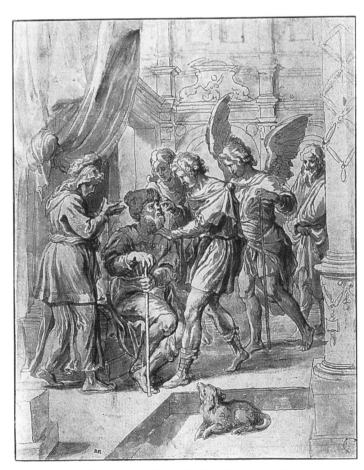

14. After Peter Paul Rubens, *Tobias Healing his Father's Blindness,* Louvre Museum.

his eyes will be opened. Smear the gall of the fish on his eyes; the medicine will make the white films shrink and peel off from his eyes, and your father will regain his sight and see the light.'"[25] The angel stands at the center of Pietro Bianchi's drawing, a long staff in his right hand, his torso open like the enormous eyelid of a fiery eye. But in a drawing after Rubens, the angel remains withdrawn [en retrait], as if hidden, behind Tobias. He too holds a staff in his left hand, the blind Tobit gripping his staff with both hands, while his wife Anna prays with her hands together: the *mise en scène* of the blind is always inscribed in a theater or theory of the hands.

Raphael seems to remain on the edge, almost in the margin, of Rembrandt's drawing (though he is at the center of a *Tobit Recovering His Sight* after Rembrandt).[26] Yet that is not this drawing's only peculiarity. The drawing remains rather sketchy. Tobias and his mother are busy doing something strange behind the old blind man, behind his back. This scene of hands, of maneuvering and manipulation, calls to mind a properly surgical operation, which I dare not, or not yet, call graphic. Tobias seems to be holding a stylus-like instrument, some sort of engraver or scalpel. In fact, when the drawing was sent from Versailles to the Louvre in 1803 it bore the inscription: "Surgeon bandaging a wounded man, washed in bister on white paper? Rembrandt." A later specification in the inventory style reads: "Tobias restoring sight to his father, idem. drawing coming from Versailles, where it was referred to by the title *Surgeon Bandaging a Wounded Man*—also attributed to Livens."

In none of the representations of this healing does the fish gall appear. It is always a matter of manipulations, of operations of touching or making contact with a hand that is either bare or armed.

Veiled light, tears and veils, the burying of bodies and eyes: before asking what tears are or what they do, it would be necessary to follow the entangled composition of these motifs in a Book that was first considered

25. Tobit 11:7–8. [It should be noted that the French translation of A. Guillaumont (Paris: Pléiade) reads "*il te verra* (he will see you)," rather than "he will see the light." The French and the English translations of the Book of Tobit in fact differ in several places. We have cited the Oxford N.R.S.V. translation throughout and have pointed out the discrepancies between the French and English only when they affect Derrida's argument. —Trans.]

26. "Tobit Recovering His Sight," after Rembrandt van Rijn, 1636, engraved by Marcenay de Ghuy. Reproduced in Michael Fried, *Absorption and Theatricality: Painting and Beholder in the Age of Diderot* (Berkeley: University of California Press, 1980), 48. [Our translation here takes into account changes made by Derrida after the first edition of the French text. —Trans.]

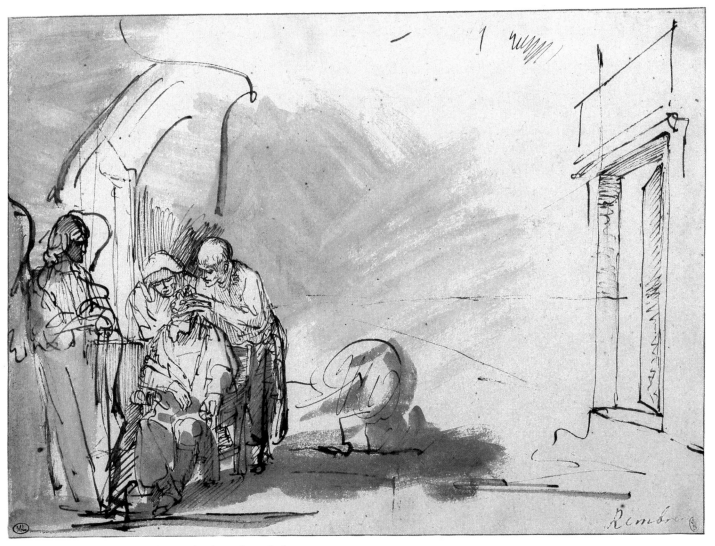

15. Rembrandt (attributed to), *Tobias Healing his Father's Blindness,* Louvre Museum.

apocryphal. The son is the light, the supplementary or excessive eye of the father, the blind man's guide, his staff even, but also the staff of the weeping mother, who constantly recalls this fact. First, after Tobias' departure:

> But his mother [Anna] began to weep, and said to Tobit, "Why is it that you have sent my child away? Is he not the staff of our hand as he goes in and out before us?" [Tobit answers her,] ". . . Your eyes will see him . . . a good angel will accompany him. . . ." So she stopped weeping.[27]

Raguel, Edna, and Sarah shed many tears upon discovering that Tobias is the son of Tobit and that this latter has lost his sight.[28] Later, when Tobias has not yet returned, Anna weeps once more: "My child has perished, and is no longer among the living. . . . Woe to me, my child, the light of my eyes, that I let you make the journey."[29] At his healing, Tobit too breaks down in tears, and what he sees first is his son. He gives thanks not simply for seeing, for seeing for the sake of seeing, but for seeing his son. He weeps in gratitude, in recognition, not so much because he finally sees but because his son restores his sight [rend la vue] by making himself [se rendre] visible: he restores his father's sight *in* making himself visible and *in order to* make himself visible, he, his son, that is to say, the light that is given as the light that is received, lent, given back, exchanged. Son means: the eyes, the two eyes:

> . . . and it made [his eyes] smart. Next, with both his hands he peeled off the white films from the corners of his eyes. Then Tobit saw his son and threw his arms around him, and he wept. . . . Then he said, "Blessed be God. . . . May his holy name be blessed throughout all the ages. . . . Now I see my son Tobias!"[30]

Son: the eyes, the two eyes [deux yeux], the name of God [Dieu]. From now on, what Tobit finally sees, it seems, is neither this or that thing, this or that person, but his very sight, that very thing, that very one, his son, who restores his sight. Could one not say that he sees in his son the very origin of his own faculty of sight? Yes and no. What restores his sight is not, in truth, his son, visible at last. Behind the son there is the angel, the one coming *to announce* the other. The *hand* of the son is guided by the

27. Tobit 5:18ff.
28. Tobit 7:6–9.

29. Tobit 10:4–5.
30. Tobit 11:12–15.

angel Raphael. Now, this latter ends up presenting himself as a being without carnal desire, perhaps even without a body: he is a simulacrum of sensible visibility. He merely "rendered himself visible," being, in truth, only a "vision." Raphael himself speaks and tells the truth of his own visibility: "'Bless God forevermore. As for me, when I was with you, I was not acting on my own will, but by the will of God. . . . Although you were watching me, I really did not eat or drink anything—but what you saw was a vision.'"[31]

It is from this "vision" of the "invisible" that he gives, immediately thereafter, the order to write: in order to give thanks *[rendre grâce],* the memory of the event *must be inscribed.* The debt must be repaid with words on parchment, which is to say, with visible signs of the invisible:

> ". . . but what you saw was a vision. So now get up from the ground, and acknowledge God *[rendez grâce à Dieu].* See, I am ascending to him who sent me. Write down all these things that have happened to you." And he ascended. Then they stood up, and could see him no more. They kept blessing God and singing his praises, and they acknowledged God for these marvelous deeds of his, when an angel of God had appeared to them.[32]

As archive of the narrative, the written story *gives thanks,* as will every drawing that draws upon the narrative. In the graphic lineage or descent from the book to the drawing, it is less a matter of telling it *like it is,* of describing or noting what one sees (perception or vision), than of *observing* the law beyond sight, of ordering truth alongside the debt, of ordering truth from the debt, of giving thanks at once to the gift and the lack, to what is due, to the faultline *[la faille]* of the *"il faut"* ["one must"], be this to the *"il faut"* of the *"il faut voir"* ["one must see," "one will have to see"] or of an *"il reste à voir"* ["it remains to be seen"], which connotes at once the overabundance and the failure *[défaillance]* of the visible, the too-much and the much-too-little, the excess and the default *[faillite].* What guides the graphic point, the quill, pencil, or scalpel is the respectful *observance* of a commandment, the acknowledgement before knowledge, the gratitude of the receiving before seeing, the blessing before the know-

31. Tobit 12:17–19. [For "what you saw was a vision," the French text reads "*je me rendais visible*" (I rendered or made myself visible). —Trans.]
32. Tobit 12:20–22.

ing. That is why I insisted on the central appearance or displacement of the angel Raphael in the healings of Tobit. Depending upon the angel's absence or presence, depending upon the place he occupies, we might classify these as "drawings with vision," "drawings without vision," etc. What happens, in Rembrandt for example, when the drawing sidelines the angel? What happens to the apparition of the invisible being who restores sight but also dictates the book? Has Raphael stepped aside because the scene is starting to become a simple, natural surgery?* Or is it because, as the *Book of Tobit* literally says, the human actors "stood up, and could see [the angel] no more" once he had given the order to give thanks?

Whether it be in writing or in drawing, in the *Book of Tobit* or in the representations related to it, the thanksgiving grace [*grâce*] of the *trait* suggests that at the origin of the *graphein* there is debt or gift rather than representational fidelity. More precisely, the fidelity of faith matters more than the representation, whose movement this fidelity commands and thus precedes. And faith, in the moment proper to it, is blind. It sacrifices sight, even if it does so with an eye to seeing at last. The performative that comes on the scene here is a "restoring of sight" rather than the visible object, rather than a constatative description of what is or what one notices in front of oneself. Truth belongs to this movement of repayment that tries in vain to render itself adequate to its cause or to the thing. Yet this latter emerges only in the hiatus of disproportion. The just measure of "restoring" or "rendering" is impossible—or infinite. Restoring or rendering is the cause of the dead, the cause of deaths, the cause of a death given or requested. Tobit is not only the man of burials, the man of "the last respects," the one who makes it his obligation to give the last shroud. This father also never stops asking his son to give him too in turn a decent burial when the time comes for him, the son, to close his father's eyes. He asks him this before *and* after his healing, before Tobias' departure *and* after his return. All this, amidst scenes of running into debt, of leaving money in trust, of repayment and giving alms:

> That same day Tobit [now blind] remembered the money that he had left in trust . . . and he said to himself, "Now I have asked for death. Why do I not call my son Tobias and explain to him about the money before I die?" Then he called his son Tobias, and when he came to him he said,

*This paragraph has been slightly modified since the first French edition. —Trans.

"My son, when I die, give me a proper burial . . . and when [Anna] dies, bury her beside me in the same grave." [33]

The prayer, the request, which was also an order, is repeated *after* the healing:

"So now, my children, I command you, serve God faithfully and do what is pleasing in his sight. . . . On whatever day you bury your mother beside me. . . . See, my son, what Nadab did to Ahikar who had reared him. Was he not, while still alive, brought down into the earth? For God repaid him to his face for this shameful treatment. Ahikar came into the light, but Nadab went into the eternal darkness, because he tried to kill Ahikar. . . ." Then they laid him on his bed, and he died; and he received an honorable funeral. When Tobias's mother died, he buried her beside his father. [34]

One might find this obscure or all too evident. But this burial rite or duty is linked to the debt and to the gift of "restoring sight." The death shroud is woven like a veil of vision. One might find this insignificant or overdetermined with meaning, but the angel Raphael, the invisible one who restores sight and who himself appears only in a "vision," is also the one who, without being seen, accompanies Tobit during burials. He recalls this during his final apparition, speaking now to the healed blind man— healed, no doubt, in recompense for his respect for the dead:

So now when you and Sarah prayed, it was I who brought and read the record of your prayer before the glory of the Lord, and likewise whenever you would bury the dead. And that time when you did not hesitate to get up and leave your dinner to go and bury the dead, I was sent to you to test you. And at the same time God sent me to heal you and Sarah your daughter-in-law. [35]

Observe that on the day when this dream of the blind and of sons, of elders and eyes, came to me, the theme of this exhibition had not yet been chosen, though I was already thinking about it. Must I recall these dates? Is it my duty to inscribe them? To whom is this due? What interest is there in describing these obscure connections?

33. Tobit 4:1–4.
34. Tobit 14:9ff.

35. Tobit 12:12–14ff.

— This really is looking like an exhibition of yourself. You are inscribing in your memoirs, in short, the chronicle of an exhibition.

— No, I would be tempted rather by the self-portrait of a blind man. The caption: "This is a drawing of me, a drawing of mine." But let me pick up my story. With the exhibition already envisaged, I have to cancel a first meeting at the Department of Drawings with Françoise Viatte, Régis Michel, and Yseult Séverac.[36] It is July 5th, and I have been suffering for thirteen days from facial paralysis caused by a virus, from what is called *a frigore* (disfiguration, the facial nerve inflamed, the left side of the face stiffened, the left eye transfixed and horrible to behold in a mirror—a real sight for sore eyes—the eyelid no longer closing normally: a loss of the "wink" or "blink," therefore, this moment of blindness that ensures sight its breath). On July 5th this trivial ailment has just begun to heal. It is finally getting better after two weeks of terror—the unforgettable itself—two weeks of vigilant medical attention (superequipped surveillance, if you hear what I mean, with instruments—anoptic or blind—that sound out, that allow one to know [*savoir*] there where one no longer sees [*voir*]: not the luminous rays of radioscopy or radiography but the play of waves and echoes, the electromyogram, by means of "galvanic stimulation of the orbicular muscles of the eyelids and lips," the measurement of the "blinking reflexes" by the "orbicular recording of the eyelids," the "Ultrasonic Cervical Assessment" with a transcranial *doppler,* echotomography searching for the "intraluminal echo," the *scanner*'s computer blindly transcribing the coded signals of the photoelectric cells).

— Things certainly do happen to you, day and night.

— You better believe it [*il faut croire*]; I will have seen my share of late, it's true. And all this is documented, I am not the only one who could witness to it. And so on July 11th I am healed (a feeling of conversion or resurrection, the eyelid blinking once again, my face still haunted by a ghost of disfiguration). We have our first meeting at the Louvre. That same evening while driving home, the theme of the exhibition hits me. All of a sudden, in an instant. I scribble at the wheel a provisional title for my own

36. They have since then guided my steps, and I owe them, along with Jean Galard, all my thanks for having done it with such clairvoyant generosity. These *Memoirs* are, naturally, dedicated to them as a sign of gratitude.

use, to organize my notes: *L'ouvre où ne pas voir* [*The Open Where Not To See*],* which becomes, upon my return, an icon, indeed a window to "open" on my computer screen.

As I told you, this must not be read as the journal of an exhibition. From all this I retain only the chance or the place for a thoughtful question: what would a journal of the blind be like? A newspaper or daily of the blind? Or else the more personal kind of journal, a diary or day-book? And what about the day, then, the rhythm of the days and nights without day or light, the dates and calendars that scan memories and memoirs? How would the memoirs of the blind be written? I say memoirs, and not yet songs, or narratives, or poems of the blind—in the great filiation of the night that buries Homer and Joyce, Milton and Borges. Let's let them wait in the background. I am satisfied for the moment with coupling them off two by two—these great, dead-eyed elders of our literary memory—as in the double rivalry of a duel. The author of *Ulysses,* after having written his own odyssey (itself haunted by a "blindman"), ends his life almost blind, one cornea operation after another. Hence the themes of the iris and glaucoma pervade *Finnegans Wake* (". . . the shuddersome spectacle of this semidemented zany amid the inspissated grime of his glaucous den making believe to read his usylessly unreadable Blue Book of Eccles, *édition de ténèbres . . .*).[37] The whole Joycean oeuvre cultivates seeing eye canes.

As for Borges, among the blind ancestors whom he identifies or claims in the gallery of Western literature, it is clearly Milton who is his rival; it is with Milton that he would like to identify himself, and it is from Milton that he awaits, with or without modesty, the noble lineage of his own blindness. For this wound is also a sign of being chosen, a sign that one must know how to recognize in oneself, the privilege of a destination, an assigned mission: in the night, by the night itself. To call upon the great tradition of blind writers, Borges thus turns round an invisible mirror. He sketches at once a celebration of memory and a self-portrait. But he de-

10

*Note that *L'ouvre* is pronounced like "Louvre." —Trans.

37. James Joyce, *Finnegans Wake* (New York: The Viking Press, 1967), 179. Compare ". . . spectacle quelque peu frissonnant de ce bouffon semi démenté, par l'épaisse crasse de son antre glauque, que l'on fit semblant de lire son *Initulyssible* parce qu'illisible Livre Bleu de Klee, édition de ténèbres . . ." (French translation, Ph. Lavergne (Paris, 1982), 194). Of necessity, the French translation loses much: not only, and this was not inevitable, the fact that "édition de ténèbres" is in French in the original text, thereby making the original language invisible in translation, invisible in its very "ténèbres"—in its shadows; but more seriously, it loses its sight, even better, the allusion to the loss of the eye: "usylessly," which is also to say, "as if without an eye," eyeless.

scribes himself by pointing to the other blind man, to Milton, especially to the Milton who authored that other self-portrait, *Samson Agonistes*. The confession is entitled *Blindness:*

> Wilde said that the Greeks claimed that Homer was blind in order to emphasize that poetry must be aural, not visual. . . . Let us go on to the example of Milton. Milton's blindness was voluntary. He knew from the beginning that he was going to be a great poet. This has occurred to other poets. . . . I too, if I may mention myself, have always known that my destiny was, above all, a literary destiny—that bad things and some good things would happen to me, but that, in the long run, all of it would be converted into words. . . . Let us return to Milton. He destroyed his sight writing pamphlets in support of the execution of the king by Parliament. Milton said that he lost his sight voluntarily, defending freedom; he spoke of that noble task and never complained of being blind. . . . He spent a good part of his time alone, composing verses, and his memory had grown. He would hold forty or fifty hendecasyllables of blank verse in his memory and then dictate them to whomever came to visit. The whole poem was written in this way. He thought of the fate of Samson, so close to his own, for now Cromwell was dead and the hour of the Restoration had come. . . . But when they brought Charles II—son of Charles I, "The Executed"—the list of those condemned to death, he put down his pen and said, not without nobility, "There is something in my right hand that will not allow me to sign a sentence of death." Milton was saved, and many others with him. He then wrote *Samson Agonistes.*[38]

A singular genealogy, a singular illustration, an illustration of oneself among all these illustrious blind men who keep each other in memory, who greet and recognize one another in the night. Borges begins with

38. "Blindness," trans. Eliot Weinberger, in *Seven Nights* (New York: New Directions, 1984), 115–17. To this conference, which ought to be quoted in its entirety, one must append a few pages entitled "L'auteur," i.e., "The Maker" (in *A Personal Anthology,* trans. Alastair Reid (New York: Grove Press, 1967), 112–14). The themes of *memory* and *descent* regularly intersect here, around a memory that was perhaps a dream: "When he realized that he was going blind, he wept . . . but one morning he awoke, saw (free of shadows) the obscure things surrounding him, and felt . . . that all this had happened to him before. . . . Then he went deep into his memory, which seemed bottomless, and managed from that dizzying descent to retrieve the lost remembrance that shone like a coin in moonlight, perhaps because he had never faced it except possibly in a dream.

"The memory was as follows: another youth had insulted him, and he had gone to his father and told him the story. His father let him talk, appearing neither to listen nor to understand; and then he took down from the wall a bronze dagger, handsome and charged with power, which the boy had secretly coveted. Now he held it in his hands, and the astonishment of possessing it wiped out the hurt he had suffered, but the voice of his father was saying, 'Let someone know you are a man,' and there was a firmness in his voice. Night

Homer; he then ends with Joyce—and, still just as modestly, with the self-portrait of the author as a blind man, as a man of memory, and this, just after an allusion to castration.

> Joyce brought a new music to English. And he said, valorously (and mendaciously) that "of all the things that have happened to me, I think the least important was having been blind." Part of his vast work was executed in darkness: polishing the sentences in his memory. . . . Democritus of Abdera tore his eyes out in a garden so that the spectacle of reality would not distract him; Origen castrated himself. I have enumerated enough examples. Some are so illustrious that I am ashamed to have spoken of my own personal case—except for the fact that people always hope for confessions and I have no reason to deny them mine. But, of course, it seems absurd to place my name next to those I have recalled.[39]

I had you observe that Borges "begins with Homer." In truth, he begins with Wilde, who was himself speaking of Homer. Now, Wilde happens to be the author of *The Picture of Dorian Gray,* a tale of murder or suicide, of *ruin* and *confession.* It is also the story of a representation that carries death: a deadly portrait first reflects the progressive ruin on the face of its model who is also its spectator, the subject being thus looked at, then condemned, by his image:

> It was his beauty that had ruined him. . . . There was blood on the painted feet, as though the thing had dripped—blood even on the hand that had not held the knife. Confess? Did it mean that he was to confess? To give himself up, and be put to death?[40]

obscured the paths. Clasping the dagger, which he felt to be endowed with magic power, he descended the sharp slope surrounding the house and ran to the sea's edge, imagining himself Ajax and Perseus, and peopling the sea-smelling dark with wounds and battles. The precise flavor of that moment was what he was looking for now; the rest did not matter to him—the insults of the quarrel, the cumbersome fight, the return with the bloodstained blade.

"Another memory, also involving night and an expectation of adventure, sprang up from that one. A woman, the first which the gods had offered him, had waited for him in the shade of a hypogeum. . . . In that night of his mortal eyes, into which he was now descending . . . [he had] an inkling of the Odysseys and Iliads which he was destined to create and leave behind, resounding in the concavity of the human memory. We know these things; but not the things he felt as he descended into the ultimate darkness."

39. "Blindness," in *Seven Nights,* 119.

40. Oscar Wilde, *The Picture of Dorian Gray and Other Writings* (New York: Bantam, 1982), 190–91.

The literature of murderous works. On the wall of the same exhibition one would have to hang Poe's *The Oval Portrait:* a portrait at once *seen* and *read,* the story of an artist who kills his drawn out, exhausted model—his wife, in fact—after having given her body over to ruin. The experience of a painter coupled with his model is that of a husband who

> . . . *would* not see that the light which fell so ghastlily in that lone turret withered the health and the spirits of his bride, who pined visibly to all but him. . . . the painter . . . wrought day and night to depict her who so loved him. . . . And he *would* not see that the tints which he spread upon the canvas were drawn from the cheeks of her who sat beside him. [The portrait just finished, the husband] grew tremulous and very pallid, and aghast, and crying with a loud voice, "This is indeed *Life* itself!" turned suddenly to regard his beloved:—*She was dead.*[41]

This is not, then, the journal of an exhibition. I was more than just honored by the invitation that was extended to me; I was intimidated, deeply worried even, by it. And I still am, no doubt well beyond what is reasonable. The anxiety was, of course, mixed with an obscure jubilation. For I have always experienced drawing as an infirmity, even worse, as a culpable infirmity, dare I say, an obscure punishment. A double infirmity: to this day I still think that I will never know *either* how to draw *or* how to look at a drawing. In truth, I feel myself incapable of following with my hand the prescription of a model: it is as if, just as I was about to draw, I no longer *saw* the thing. For it immediately flees, drops out of sight, and almost nothing of it remains; it disappears before my eyes, which, in truth, no longer perceive anything but the mocking arrogance of this disappearing apparition. As long as it remains in front of me, the thing defies me, producing, as if by emanation, an invisibility that it reserves for me, a night of which I would be, in some way, the chosen one. It blinds me while making me attend the pitiful spectacle. By *exposing me,* by *showing me up,* it takes me to task but also makes me bear witness. Whence a sort of passion of drawing, a negative and impotent passion, the jealousy of a drawing in abeyance. And which I see without seeing. The child within me wonders: how can one claim to look at both a model and the lines *[traits]* that one jealously dedicates with one's own hand to the thing itself? Doesn't one have to be blind to one or the other? Doesn't one always have

41. Edgar Allan Poe, "The Oval Portrait," in *Great Short Works of Edgar Allan Poe* (New York: Harper & Row, 1970), 358–59.

to be content with the memory of the other? The experience of this shameful infirmity comes right out of a family romance,* from which I will retain only a *trait,* a weapon and a symptom, no doubt, as well as a cause: wounded jealousy before an older brother whom I admired, as did everyone around him, for his talent as a draftsman—and for his eye, in short, which has no doubt never ceased to bring out and accuse in me, deep down in me, *apart from me,* a fratricidal desire. His works, I must say in all fraternity, were merely *copies:* often portraits done in black pencil or India ink that reproduced family photographs (I remember the portrait of my grandfather after his death, wearing a cap, with a little goatee and wirerimmed glasses) or pictures already reproduced in books (I still remember this old rabbi praying; but because my own grandfather Moses, though not a rabbi, incarnated for us the religious consciousness, a venerable righteousness placed him above the priest).

16

I suffered seeing my brother's drawings on permanent display, religiously framed on the walls of every room. I tried my hand at imitating his copies: a pitiable awkwardness confirmed for me the double certainty of having been punished, deprived, cheated, but also, and because of this even, secretly chosen. I had sent to myself, who did not yet exist, the undecipherable message of a convocation. As if, in place of drawing, which the blind man in me had renounced for life, I was called by another *trait,* this graphics of invisible words, this accord of time and voice that is called (the) word—or writing, scripture. A substitution, then, a clandestine exchange: one *trait* for the other, a *trait* for a *trait.†* I am speaking of a calculation as much as a vocation, and the stratagem was almost deliberate, by design. Stratagem, strategy—this meant war. And the fratricidal watchword: *economizing on drawing.‡* Economizing on visible drawing, on drawing as such, as if I had said to myself: as for me, I will write, I will devote myself to the words that are calling me. And even here, you can see very well that I still prefer them; I draw nets of language about drawing, or rather, I weave, using *traits,* lines, staffs, and letters, a tunic of writing wherein to capture the body of drawing, at its very birth, engaged

*For Freud's notion of the "family romance," see *The Standard Edition of the Complete Psychological Works of Sigmund Freud,* trans. James Strachey (London: Hogarth Press, 1959), 9:237–41. —Trans.

†One can hear in *"trait pour trait"* the biblical *"oeil pour oeil, dent pour dent"*—"an eye for an eye, a tooth for a tooth." —Trans.

‡*Economie du dessin* means both economy of drawing and doing without drawing—managing with drawing and managing without it. —Trans.

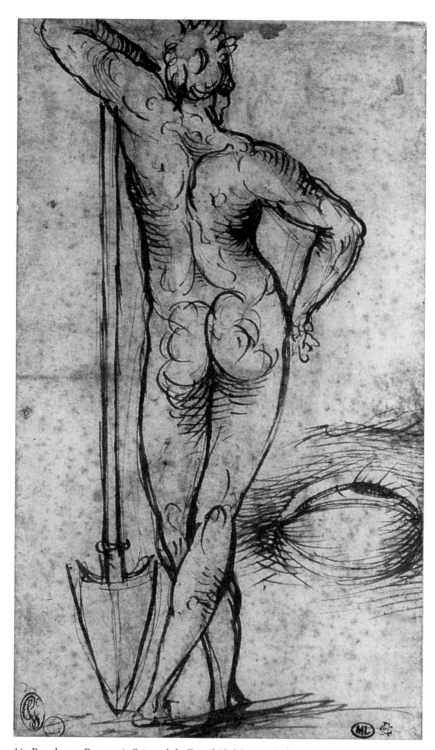

16. Bartolomeo Passarotti, *Cain and the Eye of Abel,* Louvre Museum.

as I am in understanding it without artifice. For all this happens to us, in truth, in a movement of eyes *[yeux]* and elders *[vieux]*, by the divine *[dieux]* and the dual *[deux]*, the dolor *[dueil]* and the duel *[duel]*. (Perhaps some "she" *[du "elle"]* awaits us, and some "he" *[du "il"]*, and what is "due him"—the "due isle" *["dû/île"]*—and what "due her" *["dû/elle"]*, along with the whole family of "*pers*" (greenish-blue) eyes: Athena *Glaukopis*—"piercing": Athena *Oxyderkēs* or *Gorgopis*—or "pierced." All these "per's" that we implore in secret, across the homonymic filiation of blind fathers or *pères,* of "pairs" of eyes, of sight's "perdition"—as one is given over to the hazard of signifiers or to the blind man's buff of proper names (Perseus), so generously provided, it seems, by blindfolded Fortune. Between the two series I have just mentioned, the father and the eye, the figure of the ancestor *(avus)* is drawn out. Old blind men pass by in a crowd, and this is the very experience of fathers, the space of our memories. If experience is authority, as Bataille said, is it not also blindness? It is neither a question of giving in to playful jubilation nor of victoriously manipulating words or vocables. On the contrary, you can hear them resonating all on their own, deep down in the drawing, sometimes right on its skin; because the murmurring of these syllables has already come to well up in it, bits of words parasiting it and producing interference; and in order to perceive this haunting one need only abandon oneself to the ghosts of discourse by closing one's eyes.)

Doing without drawing, then. Yet drawing always returns. Does one ever give it up? Does one ever get over drawing, is one ever done mourning it? My working hypothesis also suggested the work of mourning. The unconscious renounces or gives up nothing. I have never in my life drawn again, not even tried. Except once last winter—and I still keep the archive of this disaster—when the desire, and the temptation, came over me to sketch my mother's profile as I watched over her in her hospital bed. Bedridden for a year, surviving between life and death, almost walled up within the silence of this lethargy, she no longer recognizes me, her eyes veiled by cataracts. We can only hypothesize about the degree to which she sees, about what shadows pass before her, whether she sees herself dying or not. (Did I just spontaneously say that my mother was "walled up"? This is one of the typical figures of what could be called the rhetoric of blindness. Rilke's blind person [*die Blinde* is, this time, a woman[42]—

42. From among all Rilke's blind people, all of whom—both men and women—sing of the poetic condition, namely, of lyricism itself insofar as it opens beyond the visible, let us

note that the grammar of *l'aveugle* in French does not allow one to distinguish between *un aveugle* [a blindman] and *une aveugle* [a blindwoman]] speaks of her "eyes walled up" *[vermauerten Augen]*. These leaden walls enclose one into the night of the tomb [the blind Pharisees are "whitewashed tombs" (Matthew 23:27), while Milton's Samson presents himself as one of the living-dead, exiled from light, buried inside himself within a moving grave: "Myself my sepulchre, a moving grave, buried. . ."].[43] These walls also close one up inside a prison. Samson says that he is doubly confined, "prison within prison," no longer knowing which to "bewail" more, the literal prison of stone, or the other, even more interior prison, as if "en abyme" behind the walls of the eye. ["Which shall I first bewail, / Thy bondage or lost sight, / Prison within prison / Inseparably dark? Thou art become (O worst imprisonment) / The dungeon of thyself."][44] The confinement of the blind man can thus isolate him behind some pretty hard walls, against which he must use his hands and nails. But the abyss of isolation can also remain liquid, like the substance of the eye, like the waters of a Narcissus who would no longer see anything but himself, nothing around him. The specular isolation thus calls for the insularity

yield the floor only to a blind man from a dream. For, contrary to *Die Blinde,* this dream of the blind concerns a man. A man seems to make another man speak in order to give him back his eyes. These eyes are stars. Inverting an astral or ocular allegory as old as the sky itself, he gives the man back his eyes by answering the question raised by a young girl. The girl had said to a young blind man, who "was obviously making an effort to wake up," though unsuccessfully, and whose "eye" "seemed empty": "'That's no good,' . . . her transparent voice scintillating with dissolved laughter, 'you can't wake up, if your eyes are not back again.' I was about to ask, what did she mean by that? But all at once I understood. Of course. I recalled a young Russian worker from the country who still held the belief, when he came to Moscow, that the stars were the eyes of God and the eyes of the angels. They talked him out of it. They could not contradict it at all, but they could talk him out of it. And rightly so. For the stars are the eyes of human beings, which rise out of their closed lids and become bright and regain their strength. And that is why all the stars are above the countryside, where everyone is sleeping, and over the town there are only a few, because there are so many restless people there, weeping and reading, laughing and watching, who keep their eyes." (Rainer Maria Rilke, *From the Dream-Book,* "The Seventh Dream," in *Selected Works,* trans. G. Craig Houston [New York: New Directions, 1967], 23–24). In *Gong,* Rilke also writes: "We must close our eyes and renounce our mouths, / remain mute, blind, dazzled: / Vibrating space, as it reaches us / demands from our being only the ear." This is from *Poésie (Oeuvres,* 2, Paris, 1972), edited by Paul de Man, the author of *Blindness and Insight* (Minneapolis: University of Minnesota Press, 1983), who also cites these lines in *Allegories of Reading* (New Haven: Yale University Press, 1979), 55, n. 40.

43. John Milton, *Samson Agonistes and Shorter Poems,* ed. A. E. Barker (Arlington Heights, Illinois: AHM Publishing Corporation, 1950), line 102.

44. Ibid., lines 151–56.

of the image, or even, to reflect the "abandonment" of the blind man and his mourning solitude, the image of the island: "I am an island," she says. *Die Blinde:* "*Ich bin von allem verlassen— / Ich bin eine Insel.* [I am abandoned by all.— / I am an island.]" And to the stranger come from the sea: "*Ich bin eine Insel und allein.* [I am an island and alone.]"[45] Yet solitude is "rich," insularity does not isolate or "deprive" one of anything, since "all the colors are translated *[übersetzt]* into sounds and smells *[in Geräusch und Geruch].*")

And so we are in July, after the recovery. Now that the theme is chosen (it is necessary to go quickly now and sketch with broad strokes), I hesitate between two paradoxes, two great "logics" of the invisible at the origin of drawing. Two thoughts of or about drawing thus take shape, and, by correlation, two "blindnesses."

— Give them names, for memory's sake.

— I shall name them the *transcendental* and the *sacrificial.* The first would be the invisible condition of the possibility of drawing, draw*ing* itself, the drawing of drawing. It would never be thematic. It could not be posited or taken as the representable *object* of a drawing. The second, then, the sacrificial event, that which comes to or meets the eyes, the narrative, spectacle, or representation of the blind, would, in becoming the *theme* of the first, reflect, so to speak, this impossibility. It would represent this unrepresentable. Between the two, in their fold, the one repeating the other without being reduced to it, the *event* can give rise to the speech of narrative, to myth, prophecy, or messianism, to the family romance or to the scene of everyday life, thus providing drawing with its thematic objects or spectacles, its figures and heroes, its *pictures* or *depictions of the blind [tableaux d'aveugle].* Drawing counts on *[table]* the representations procured by the event, by what may have come or happened to the eyes—or to sight, which is not necessarily the same thing. It will always remain to be seen whether one of the two blindnesses does not hasten or precipitate the other. And whether, for example, what I expose right away under the name of transcendental blindness is not motivated by the violence of a sacrificial economy: eyes gouged out or burned, castration with all its abocular metonymies, resentment or revenge against brothers who have

45. Rainer Maria Rilke, "Die Blinde," *Gesammelte Werke* (Leipzig: Insel, 1930), vol. 2, 153–58.

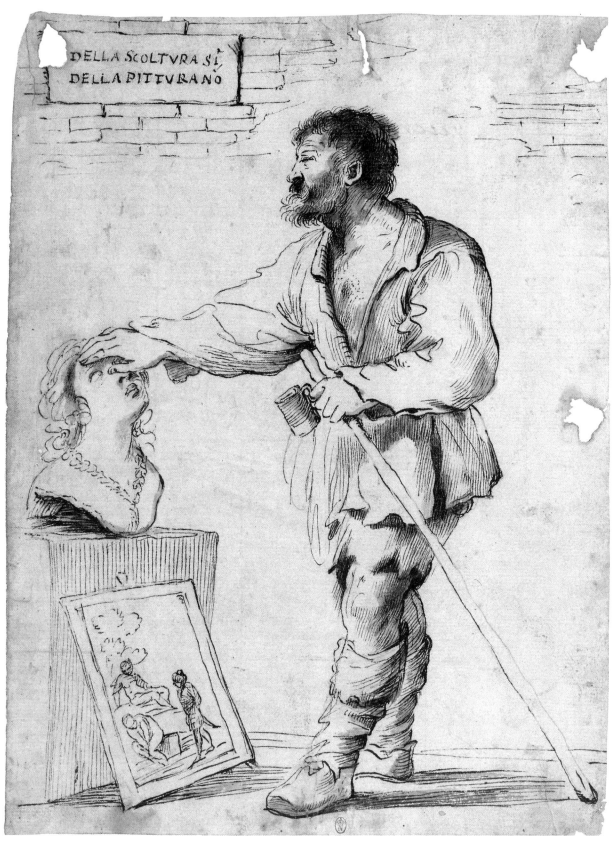

DELLA SCOLTVRA SI,
DELLA PITTVRA NO

17. School of Guercino, *Della Scoltura Si, Della Pittura No,* Louvre Museum.

the power to draw, sublimation or interiorization (the arts of the invisible, the intelligible light, the interior or supernatural revelation).

How does one demonstrate that the draftsman is blind, or, rather, that in or by drawing he does not see? Do we know of any blind draftsmen? There are deaf musicians, some great ones. There are also great blind singers and poets, about whom we will have more to say later; and blind sculptors:[46] observe the drawing from the school of Guercino, *Della Scoltura Si, Della Pittura No.* This beggar has all the characteristics of the blind **17** men in the Scriptures. His gesture is that of a sculptor; for while he holds a staff in his left hand, he recognizes with his right hand the bust of a woman who might well be blind herself, her face offering itself to a caress, her eyes turned upwards, disoriented like the man's but in a movement that wavers between imploring and ecstacy ("I ask myself—what are they seeking in the heavens, all those blind men?" the ultimate question for Baudelaire's "faintly ridiculous" *Blind Men,* "terrifying and strange as sleep-walkers").* But if the blind man's mute fingers indicate "yes" to sculpture and "no" to painting, speech is enough to invert things—and to convert them. Speech, which is to say, rhetoric.

> It has been much disputed which is the most Excellent of the two Arts, Sculpture, or Painting, and there is a Story of its having been left to the determination of a Blind man, who gave it in favour of the Latter, being told that what by Feeling seem'd to him to be Flat, appear'd to the Eye as Round as its Competitor.[47]

*Charles Baudelaire, *The Complete Verse,* vol. 1, trans. Francis Scarfe (London: Anvil Press, 1986), 185. —Trans.

46. Roger de Piles tells "The Story of a Blind Sculptor Who Made Wax Portraits." Once again, it is a story of memory: ". . . 'One day, having met him in the Justinian Palace where he was copying a statue of Minerva, I took the opportunity to ask him whether he did not see just a little bit in order to copy as exactly as he did. I see nothing, he told me, and my eyes are at the tip of my fingers. . . . I feel out my original, he said, I study its dimensions, its protusions and cavities: I try to retain them *in my memory,* then I put my hand to the wax, and by the comparison that I make between one and the other, going back and forth between them several times with my hand, I finish my work as best as I can. . . . But without going any further, we have in Paris a portrait by his hand, that of the late Monsieur Hesselin, head of the Bureau of Monies, who was so happy with it and found the work so marvelous that he begged the author to have himself painted so that he could take his portrait back to France and thereby *conserve his memory.'* . . . I noticed that the Painter had put an eye at the tip of each of his fingers in order to show that the eyes he had elsewhere were totally useless to him." *Cours de peinture par principes,* preface by Jacques Thuillier (Paris, 1989), 161ff (my emphasis). This narrative is used to support a thesis about chiaroscuro that we cannot reconstitute here.

47. Jonathan Richardson, "An Argument in behalf of the Science of a Connoisseur," in *Two Discourses: 1719* (London: Scholar Press, 1972), 23–24.

Leaning against the base of the statue, *lower* than it, as if abandoned on the ground, (the) drawing is indeed *put down:* put down, subordinated in the hierarchy of the arts, submitted to the judgment of the blind man who touches but also listens to what he is told about the relief. But what, in fact, is the blind man touching? Recognizing the lines of the face at the level of the eyes, looking them in the face with his hand, but as if from memory, he puts his fingers on the forehead of the other: a loving gesture or a blessing, a protective gesture too (he seems to be hiding or closing her eyes: you don't see, don't look, I'm closing your eyes, you see: what is one doing when one closes the other's eyes?). Unless one imagines him, like Pygmalion animating a statue, in the process of restoring sight by touching: a blind man restoring sight to a blind woman (you don't see, now see!, you, you see, you have seen, you will have seen, you already saw—you are already living *[tu vis déjà]*). And it just so happens that the eyes of sculpture are always closed, "walled up" in any case, as we were saying, or turned inward, more dead than alive, scared stiff, more dead than the eyes of masks.

But what is a mask? We have yet to speak of the blind man's memory as the *experience of the mask.*

— Let me stop you for a moment before you go too far. If we can recall *no blind* draftsman, none that is literally deprived of sight and eyes *(ab oculis),* is it not going against common sense, giving in to an easy provocation, to claim exactly the opposite, i.e., that every draftsman is blind? No one will dispute that the draftsman is prey to a devouring proliferation of the invisible, but is that enough to make him into a blind man? Is it enough to justify this counter-truth? Monet himself only *almost,* at the end, lost his sight.

— We are talking here about drawing, not painting. From this point of view, there are, it seems to me, at least *three* types of powerlessness for the eye, or let us say, three *aspects,* to underscore once again with a *trait* that which gives the experience of the gaze *(aspicere)* over to blindness. *Aspectus* is at once gaze, sight, *and* that which meets the eyes: on one side, the spectator, and on the other, the aspect, in other words, the spectacle. In English, *spectacles* are glasses. This powerlessness is not an impotence or failure; on the contrary, it gives to the experience of drawing its *quasitranscendental* resource.

I would see the *first aspect*—as we will call it—in the *aperspective of the*

graphic act. In its originary, pathbreaking *[frayage]* moment, in the *tracing* potency of the *trait,* at the instant when the point at the point of the hand (of the body proper in general) moves forward upon making contact with the surface, the inscription of the inscribable is not seen. Whether it be improvised or not, the invention of the *trait* does not follow, it does not conform to what is presently visible, to what would be set in front of me as a theme. Even if drawing is, as they say, mimetic, that is, reproductive, figurative, representative, even if the model is presently facing the artist, the *trait* must proceed in the night. It escapes the field of vision. Not only because it *is not yet* visible,[48] but because it does not belong to the realm of the spectacle, of spectacular objectivity—and so that which it makes happen or come *[advenir]* cannot in itself be mimetic. The heterogeneity between the thing drawn and the drawing *trait* remains abyssal, whether it be between a thing represented and its representation or between the model and the image. The night of this abyss can be interpreted in two ways, either as the eve or the memory of the day, that is, as a reserve of visibility (the draftsman does not presently see but he has seen and will see again: the aperspective as the anticipating perspective or the anamnesic retrospective), or else as radically and definitively foreign to the phenomenality of the day. This heterogeneity of the invisible to the visible can haunt the visible as its very possibility. Whether one underscores this with the words of Plato or Merleau-Ponty, the visibility of the visible cannot, by definition, be seen, no more than what Aristotle speaks of as the diaphanousness of light can be. My hypothesis—remember that we are still within the logic of the hypothesis—is that the draftsman always sees himself to be prey to that which is each time universal and singular and would thus have to be called the *unbeseen,* as one speaks of the unbeknownst. He recalls it, is called, fascinated, or recalled by it. Memory or not, and forgetting as memory, in memory and without memory.

On the one hand, then, *anamnesis: anamnesis of memory itself.* Baude- **18**

48. "What is it to draw?, asks Van Gogh. "How do we do it? It is the act of clearing a path for oneself through an invisible iron wall." This letter is cited by Artaud (*Oeuvres Complètes,* 13:40). In an essay devoted to the drawings and portraits of Antonin Artaud ("Forcener le subjectile," in *Dessins et portraits d'Antonin Artaud,* ed. Jacques Derrida and Paule Thévenin [Paris: Gallimard, 1986]), I try in particular to interpret the relationship between what Artaud calls drawing's necessary awkwardness or *mal-adresse* in the path-clearing of the invisible and the rejection of a certain theological order of the visible, the rejection of another *maladresse* of God as "the art of drawing." It is as if Artaud here countersigned Rimbaud's willful blindness: "Yes, my eyes are closed to your light. I am not Christian."

18. Charles Baudelaire, *Self-Portrait,* Louvre Museum, Orsay Museum Collection.

laire relates the invisibility of the model to the memory that will have borne that model. He "restores" invisibility to memory. And what the poet of *The Blind* says is all the more convincing in that he speaks of the graphic *image*, of representative drawing. This goes *a fortiori* for the other kind of drawing. One would have to cite here all of *Mnemonic Art.* For example:

> I refer to Monsieur G's method of draftsmanship. He draws from memory and not from the model. . . . [A]ll good and true draftsmen draw from the image imprinted on their brains, and not from nature. To the objection that there are admirable sketches of the latter type by Raphael, Watteau, and many others, I would reply that these are notes—very scrupulous notes, to be sure, but mere notes, none the less. When a true artist has come to the point of the final execution of his work, the model would be more of an embarassment than a help to him. It even happens that men such as Daumier and Monsieur G, long accustomed to exercising their memory and storing it with images, find that the physical presence of the model and its multiplicity of details disconcerts and as it were paralyzes their principal faculty.[49]

Baudelaire, it is true, interprets memory as a natural reserve, without history, tragedy, or event, as, in his words, the *naturally sacrificial* matrix of a visible order that is selected, chosen, filtered. It breaks with the present of visual perception only in order to keep a better eye on drawing. Creative memory, schematization, the time and schema of Kant's transcendental imagination, with its "synthesis" and its "ghosts." "Duel" is also one of Baudelaire's words, a duel, as in my dream, between two blind men—and for the appropriation of excess: the (no)-more-sight *[le plus-de-vue]*, the visionary vision of the *seer* who sees beyond the visible present, the overseeing, sur-view, or survival of sight. And the draftsman who trusts in sight, in present sight, who fears the suspension of visual perception,

49. Charles Baudelaire, "Mnemonic Art," in *The Painter of Modern Life and Other Essays,* trans. and ed. Jonathan Mayne (New York: Da Capo Press; Reprint of Phaidon Press Ltd., 1986), 16–17. Two references have been suggested for the poem *Les aveugles [The Blind].* For essential reasons, which have to do with the structure of reference and the poem, these must remain nothing more than hypotheses. The first concerns an etching or lithograph after the painting of Bruegel the Elder ("The Parable of the Blind" in the Naples Museum, a copy of which was acquired by the Louvre in 1893). The other hypothesis of reference refers to *Hoffman, Contes posthumes* (1856), a book by Champfleury. In the note that he devotes to this question, Claude Pichois recalls that in this book "the *I* declares that the blind can be recognized by the way they tilt their heads upwards," while "the *Cousin* says to him that the interior eye seeks to perceive the eternal light that shines in the other world" (Pléiade, t. 1: 1021).

who does not want to be done with mourning it, who does not want to let it go, this draftsman begins to go blind simply through the fear of losing his sight. This cripple is already on the road to blindness; he is "near-sighted or far-sighted." The Baudelairian rhetoric also makes use of political tropes or figures:

> *In this way a duel* (my emphasis, J. D.) is established between the will to see everything and forget nothing and the faculty of memory, which has formed the habit of a lively absorption of general color and of silhouette, the arabesque of contour. An artist with a perfect sense of form but accustomed to relying above all on his memory and his imagination will find himself at the mercy of a riot of details all clamoring for justice with the fury of a mob in love with absolute equality. All justice is trampled under foot; all harmony *sacrificed* (my emphasis, J. D.) and destroyed; many a trifle assumes vast proportions; many a triviality usurps the attention. The more our artist turns an impartial eye on detail, the greater the state of anarchy. Whether he be near-sighted or far-sighted, all hierarchy and all subordination vanishes. This is an accident that is often conspicuous. . . .

And so, for Baudelaire, it is the *order of memory* that precipitates, beyond present perception, the absolute speed of the instant (the time of the *clin d'œil* that buries the gaze in the batting of an eyelid, the instant called the *Augenblick,* the wink or blink, and what drops out of sight in the twinkling of an eye),* but also the "synthesis," the "phantom," the "fear," the fear of seeing *and* of not seeing what one must not see, hence the very thing that one must see, the fear of seeing without seeing the eclipse between the two, the "unconscious execution," and especially the figures that substitute one art for another, the analogical or *economic* (i.e., the familial) rhetoric of which we were just speaking—the *trait*-for-a-*trait.*

> Thus two elements are to be discerned in Monsieur G's execution: the first, an intense effort of memory that evokes and calls back to life—a memory that says to everything, "Arise, Lazarus"; the second, a fire, an intoxication of the pencil or the brush, amounting almost to a frenzy. It is the fear of not going fast enough, of letting the phantom escape before the synthesis has been extracted and pinned down; it is that terrible fear that takes possession of all great artists and gives them such a passionate desire to become masters of every means of expression so that the orders

*"Wink," "blink," and "in the twinkling of an eye" are all in English in the original. —Trans.

of the brain may never be perverted by the hesitations of the hand and that finally execution, ideal execution, may become as unconscious and *spontaneous* as digestion is for a healthy man after dinner.

By attributing the origin of drawing to memory rather than to perception, Baudelaire is, in turn, making a show of memory. He is writing himself into an iconographic tradition that goes back to at least Charles Le Brun.[50] In this tradition, the origin of drawing and the origin of painting give rise to multiple representations that substitute memory for perception. First, because they are *re*presentations, next, because they are drawn most often from an exemplary narrative (that of Butades, the young Corinthian lover who bears the name of her father, a potter from Sicyon), and finally, because the narrative relates the origin of graphic representation to the absence or invisibility of the model. Butades does not see her lover, either because she turns her back to him—more abiding than Orpheus— or because he turns his back to her, or again, because their gazes simply cannot meet (see, for example, J. B. Suvée's *Butades or the Origin of Drawing*):* it is as if seeing were forbidden in order to draw, as if one drew only **19** on the condition of not seeing, as if the drawing were a declaration of love destined for or suited to the invisibility of the other—unless it were in fact born from seeing the other withdrawn from sight. Whether Butades follows the *traits* of a shadow or a silhouette—her hand sometimes guided

*The painting is sometimes referred to in English as *The Daughter of Butades Drawing the Shadow of Her Lover.* —Trans.

50. This is the hypothesis of George Levitine, who is trying to refine or rectify the hypotheses of Robert Rosenblum in his very rich study, "The Origin of Painting: A Problem in the Iconography of Romantic Classicism," *The Art Bulletin,* vol. 39 (1957). Rosenblum had considered Runciman's *The Origin of Painting* (1771) to have inaugurated this inexhaustible "iconographic tradition" in memory of Butades, the young Corinthian woman who bore her father's name and who, "facing a separation from her lover for some time, noticed on a wall the shadow of this young man sketched by the light of a lamp. Love inspired in her the idea of keeping for herself this cherished image by tracing over the shadow a line that followed and precisely marked its outline. This lover's father was a potter from Sicyon named *Butades. . .*" (Antoine d'Origny, cited by Rosenblum, "Origin of Painting," n. 21). Let us note that, in the topography that is here traced back, the apparatus of the origin of drawing recalls quite precisely that of the Platonic speleology. In his "Addenda" to Rosenblum's study (in *The Art Bulletin,* vol. 40 [1958]), Levitine directs us back to some anterior, and thus, in sum, more originary "origins of drawing." The first would be an engraving inspired by a drawing of Charles Le Brun (before 1676), the other, an engraving inspired by a drawing of Charles-Nicolas Cochin, Jr. (1769). In both cases, one sees the young Corinthian woman, her lover, and Cupid. In Le Brun's version Cupid guides Butades' hand. On the theme of blind love *(caecus amor, caeca libido, caeca cupido, caecus amor sui),* on the so very paradoxical story of Cupid's "eyes," which were not always "blindfolded," I can only refer here to Panofsky's fine treatment in *Studies in Iconology,* 151ff.

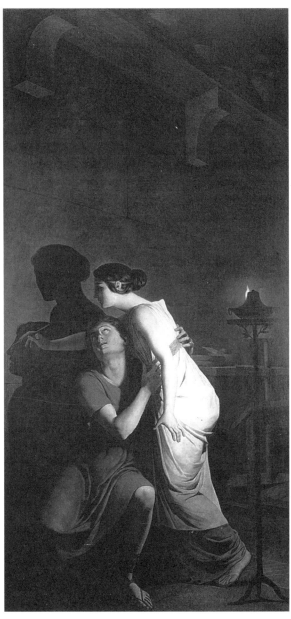

19. Joseph-Benoît Suvée, *Butades or the Origin of Drawing*, Bruges, Groeningemuseum.

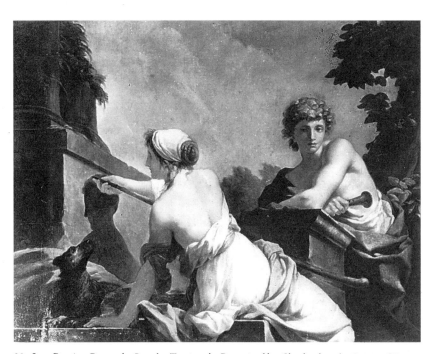

20. Jean-Baptiste Regnault, *Butades Tracing the Portrait of her Shepherd or the Origin of Painting*, Palace of Versailles.

by Cupid (a Love who sees and, here, is not blindfolded)—or whether she draws on the surface of a wall or on a veil,[51] a *skiagraphia* or shadow writing in each case inaugurates an art of blindness. From the outset, perception belongs to recollection. Butades writes, and thus already loves in nostalgia. Detached from the present of perception, fallen from the thing itself—which is thus divided—a shadow is a simultaneous memory, and Butades' stick is a staff of the blind. Let's follow its course in Regnault's picture *(Butades Tracing the Portrait of Her Shepherd or the Origin of Painting),* as we have done for all the drawings of the blind: it goes back and forth between love and drawing. Rousseau wanted to grant it speech, to give it the floor. In the *Essay on the Origin of Languages,* he writes:

20

> Love, it is said, was the inventor of drawing. Love might also have invented speech, though less happily. Dissatisfied with speech, love disdains it: it has livelier ways of expressing itself. How many things the girl who took such pleasure in tracing her Lover's shadow was telling him! What sounds could she have used to convey this movement of the stick?[52]

On the other hand, and in anamnesis itself, there is *amnesia,* the orphan of memory, for the invisible can also lose its memory, as one loses one's parents. On a different trail, which perhaps comes down to the same one, the draftsman would be given over to this other invisibility, given over to it in the same way that a hunter, *himself in relentless pursuit,* becomes a fascinating lure for the tracked animal that watches him. In order to be absolutely foreign to the visible and even to the potentially visible, to the possibility of the visible, this invisibility would still inhabit the visible, or rather, it would come to haunt it to the point of being confused with it, in order to assure, from the specter of this very impossibility, its most proper resource. The visible *as such* would be invisible, not as visib*ility,* the *phenomenality or essence* of the visible, but as the singular body of the

51. Nougaret in fact notes in his *Anecdotes des Beaux-Arts* (1776) that if the roles are sometimes reversed (and it is Butades' lover who is drawing), Butades "took advantage of her lover's fortunate stratagem" and herself drew the silhouette not on a wall but on a *veil,* "which she knew how to *keep* with the greatest of care" (cited by Levitine, *Art Bulletin* 40 [1958]: 330. My emphasis (J. D.)).

52. Permit me to refer to a chapter in *Of Grammatology,* trans. Gayatri Chakravorty Spivak, (Baltimore: The Johns Hopkins University Press, 1976) that revolves around this text: "That Movement of the Wand . . ." (229ff.).

visible itself, *right on* the visible—so that, by emanation, and as if it were secreting its own *medium,* the visible would produce blindness. Whence a program for an entire rereading of the later Merleau-Ponty. Let us be satisfied, for lack of space, with a few indications from *The Visible and the Invisible.* Rather than recall the "teleperception" or the four "layers" of the invisible, which, as Merleau-Ponty explains,[53] cannot be *"logically"* brought together—(1) "what is not actually visible, but could be," (2) the framework of the nonvisible existentials of the visible, (3) the tactile or kinesthetic, (4) the sayable, the *"lekta"* or the *"Cogito"*—I would rather have followed the traces of *absolute* invisibility. To be the other of the visible, *absolute* invisibility must neither take place elsewhere nor constitute another visible, that is, something that does not yet appear or has already disappeared—something whose spectacle of monumental ruins would call for reconstitution, regathering from memory, rememberment. This nonvisible does not describe a phenomenon that is present elsewhere, that is latent, imaginary, unconscious, hidden, or past; it is a "phenomenon" whose inappearance is of another kind; and what we have here seen fit to call transcendentality is not unrelated to what Merleau-Ponty speaks of as "pure transcendence, without an ontic mask":

> January, 1960. Principle: not to consider the invisible as an *other visible* "possible," or a "possible" visible for an other. . . . The invisible is *there* without being an *object,* it is pure transcendence, without an ontic mask. And the "visibles" themselves, in the last analysis, they too are only centered on a nucleus of absence—
>
> Raise the question: the invisible life, the invisible community, the invisible other, the invisible culture.
>
> Elaborate a phenomenology of "the other world," as the limit of a phenomenology of the imaginary and the "hidden"[54]—
>
> [May 1960]. When I say that every visible is invisible, that perception is imperception, that consciousness has a *"punctum caecum,"* that to see is always to see more than one sees—this must not be understood in the sense of a *contradiction*—it must not be imagined that I add to the visible . . . a nonvisible. . . . —One has to understand that it is visibility itself that involves a nonvisibility.[55]

53. Maurice Merleau-Ponty, *The Visible and the Invisible,* trans. Alphonso Lingis (Evanston: Northwestern University Press, 1968), 257.

54. *The Visible,* 229.

55. Ibid., 247.

And again:

> *What* [consciousness] does not see it does not see for reasons of principle; it is because it is consciousness that it does not see. *What* it does not see is what in it prepares the vision of the rest (as the retina is blind at the point where the fibers that will permit the vision spread out into it).[56]
>
> To touch *oneself,* to see *oneself* . . . is not to apprehend oneself as an ob-ject, it is to be open to oneself, destined to oneself (narcissism)—. . . .
>
> The feeling that one feels, the seeing that one sees, is not a thought of seeing or of feeling, but vision, feeling, mute experience of a mute meaning[57]—

The *aperspective* thus obliges us to consider the objective definition, the anatomico-physiology or ophthalmology of the *"punctum caecum,"* as itself a mere image, an analogical index of vision itself, of vision in general, of that which, seeing itself see, is nevertheless not reflected, cannot be "thought" in the specular or speculative mode—and thus is blinded because of this, blinded at this point of "narcissism," at that very point where it sees itself looking.

— I'll agree that, at its originary point, the *trait* is invisible and the draftsman is blind to it, but what about afterwards, once the line has been traced?

— Let's look now at the *second aspect.* It is not an aftereffect, a second or secondary aspect. It appears, or rather disappears, without delay. I will name it the *withdrawal [retrait] or the eclipse, the differential inappearance of the trait.* We have been interested thus far in the act of tracing, in the tracing of the *trait.* What is to be thought now of the *trait once traced?* That is, not of its pathbreaking course, not of the inaugural path of the trace, but of that which remains of it? A tracing, an outline, cannot be seen. One should in fact not see it (let's not say however: "One *must* not see it") insofar as all the colored thickness that it retains tends to wear itself out so as to mark the single edge of a contour: between the inside and the outside of a figure. Once this limit is reached, there is nothing

56. Ibid., 248.
57. Ibid., 249; (in addition to the pages cited, see also 214–19, 225, 242ff.).

more to see, not even black and white, not even figure/form, and this is the *trait,* this is the line itself: which is thus no longer what it is, because from then on it never relates to itself without dividing itself just as soon, the divisibility of the *trait* here interrupting all pure identification and forming—one will have no doubt understood it by now—our *general hypothec** for all thinking about drawing—inaccessible in the end, at the limit, and *de jure.* This limit is never presently reached, but drawing always signals toward this inaccessibility, toward the threshold where only the surroundings of the *trait* appear—that which the *trait* spaces by delimiting and which thus does not belong to the *trait. Nothing belongs to the trait,* and thus, to drawing and to the thought of drawing, not even its own "trace." Nothing even participates in it. The *trait* joins and adjoins only in separating.

Is it by chance that in order to speak of the *trait* we are falling back upon the language of negative theology or of those discourses concerned with naming the withdrawal *[retrait]* of the invisible or hidden god? The withdrawal of the One whom one must not look in the face, or represent, or adore, that is, idolize under the *traits* or guise of the icon? The One whom it is even dangerous to name by one or the other of his proper names? The end of iconography. The memory of the *drawings-of-the-blind [dessins-d'aveugles]*—it has been only too clear for quite some time now—opens up like a God-memory *[mémoire-Dieu].*† It is theological through and through, to the point, sometimes included, sometimes excluded, where the self-eclipsing *trait* cannot even be spoken about, cannot even say itself in the present, since it is not gathered, since it does not gather itself, into any present, "I am who I am" (a formula whose original grammatical form, as we know, implies the future). The outline or tracing separates and separates itself; it retraces only borderlines, intervals, a spacing grid with no possible appropriation. The *experience* or *experimenting* of drawing (and experimenting, as its name indicates, always consists in journeying beyond limits) at once crosses and institutes these borders, it invents the *Shibboleth* of these passages (the chorus of *Samson Agonistes* recalls that which links the *Shibboleth,* this circumcision of the tongue, of language, to the

*Though *hypothèque* would be most commonly translated as "mortgage," we have opted for the relatively obsolete English term hypothec to preserve the relationship to hypothesis. —Trans.

†*Mémoire-Dieu* evokes both *un prie-Dieu,* a low reading desk with a ledge that sometimes opens out for kneeling at prayer, and *mémoire d'yeux*—an eye-memory. —Trans.

death sentence: ". . . when so many died / Without reprieve adjudged to death, / For want of well pronouncing Shibboleth").[58]

The linear limit I am talking about is in no way *ideal* or *intelligible*. It divides itself in its ellipsis; *by leaving* itself, and *starting from* itself, it takes leave of itself, and establishes itself in no ideal identity. In this twinkling of an eye, the ellipsis is not an object but a blinking of the difference that begets it, or, if you prefer, a *jalousie* (a blind) of *traits* cutting up the horizon, *traits* through which, *between* which, you can observe without being seen, you can see between the lines, if you see what I mean: the law of the inter-view. For the same reason, the *trait* is not *sensible,* as a patch of color would be. Neither intelligible nor sensible. We are speaking here of graphic and not color blindness, of drawing and not painting, even if a certain painting can wear itself out by painting drawing, indeed by representing—in order to make it into a picture—the allegory of an "origin of drawing." For if we *left* the Platonic cave a while back, it was not in order finally to see the *eidos* of the thing itself after a conversion, anabasis, or anamnesis. We left the cave behind because the Platonic speleology misses, is unable to take into account if not to see, the inappearance of a *trait* that is neither sensible nor intelligible. It misses the *trait* precisely because it believes that it sees it or lets it be seen. The lucidity of this speleology carries within it another blind man, not the cave dweller, the blind man deep down, but the one who closes his eyes to *this* blindness—*right here.* (Let us leave for another occasion the treatment Plato reserves for those great blind men Homer and Oedipus.)

"Before" *["avant"]* all the "blind spots" that, literally or figuratively, organize the scopic field and the scene of drawing, "before" all that can happen *to* sight, "before" all the interpretations, ophthalmologies, and theo-psychoanalyses of sacrifice or castration, there would thus be the ecliptic rhythm of the *trait,* the blind *[jalousie],* the abocular contraction that lets one see "from-since" *["depuis"]* the unbeseen. "Before" and "from-since": these draw in time or space an order that does not belong to them—is this not all too clear?

— If this was indeed the initial idea for the exhibition, one will always be able to say, without fear of self-deception, that you are in fact seeking to transcendentalize, that is, to ennoble an infirmity or an impotence: does not your blindness to drawing respond to a universal necessity? Is it

58. *Samson Agonistes,* lines 287–89.

not the response *par excellence* to an essence of the *trait,* to an invisibility inscribed right on the *trait?* Would you not claim in your jealous, even envious passion, in your wounded impotence, to be more faithful to the *trait,* to the *trait* in its most refined end or finality? As for the "great draftsman"—to follow your suggestion—does he not also try in vain, up to the point of exhausting a *ductus* or stylus, to capture this withdrawal *[retrait]* of the *trait,* to remark it, to sign it finally—in an endless scarification?

— But say I admitted this, would it be enough to disqualify my hypothesis? This rhetoric of avowal or confession in which you would like to confine me leads us to the *third aspect: the rhetoric of the trait.* For is it not the withdrawal *[retrait]* of the line—that which draws the line back, draws it again *[retire],* at the very moment when the *trait* is drawn, when it draws away *[se tire]*—that which grants speech? And at the same time forbids separating drawing from the discursive murmur whose trembling transfixes it? This question does not aim at restoring an authority of speech over sight, of word over drawing, or of legend over inscription.* It is, rather, a matter of understanding how this hegemony could have imposed itself. Wherever drawing is consonant with and articulated by a sonorous and temporal wave, its rhythm composes with the invisible: even before a Gorgon's mask resounds (for a terrible cry sometimes accompanied its gaze), even before it turns you stone blind. It is still by way of figure that **44** we speak of rhetoric, in order to point out with a supplementary trope this huge domain: the drawing of men. For we here reserve the question of what is obscurely called the animal—which is not incapable of traces. The limit that we leave here in the dark appears all the more unstable since it is there that we necessarily come across the "monstrosities" of the eye, zoo-theo-anthropomorphic figures, shifting or proliferating transplants or grafts, unclassifiable hybrids of which the Gorgons and Cyclopes are only the best known examples. It is said that the sight of certain animals is more powerful, sharper—more cruel, too—than man's, and yet that it lacks a gaze.

The drawing of men, in any case, never goes without being articulated with articulation, without the order being given with words (recall the angel Raphael), without some order, without the order of narrative, and

**Une légende* is not only a legend but a caption or title of a painting. —Trans.

thus of memory, without the order to bury, the order of prayer, the order of names to be given or blessed. Drawing comes in the place of the name, which comes in the place of drawing: in order, like Butades, to hear oneself call the other or be called (by) the other. As soon as a name comes to haunt drawing, even the without-name of God that first opens up the space of naming, the blind are tied in with those who see. An internal duel breaks out at the very heart of drawing.

The *transcendental retrait* or *withdrawal* at once calls for and forbids the self-portrait. Not that of the author and presumed signatory, but that of the "source-point" of drawing, the eye and the finger, if you will. This point is represented and eclipsed at the same time. It lends itself to the autograph of this wink or *clin d'oeil* that plunges it into the night, or rather, into the time of this waning or declining day wherein the face is submerged: it gets carried away, it decomposes itself or lets itself be devoured by a mouth of darkness. Certain self-portraits of Fantin-Latour show this. Or rather, they would be the figures or the de-monstration of this. Sometimes invisibility is *shared out [s'y partage]*, if one can say this, **21–27** right between the two eyes. There is *on the one hand [d'une part]* the monocular stare of a narcissistic cyclops: a single eye open, the right one, fixed firmly on its own image. It will not let it go, but that's because the prey necessarily eludes it, making off with the lure. The *traits* of a self-portrait are also those of a fascinated hunter. The staring eye always resembles an eye of the blind, sometimes the eye of the dead, at that precise moment when mourning begins: it is still open, a pious hand should soon come to close it; it would recall a portrait of the dying. Looking at itself seeing, it also sees itself disappear right at the moment when the drawing tries desperately to recapture it. For this cyclops eye sees nothing, nothing but an eye that it thus prevents from seeing anything at all. Seeing the seeing and not the visible, it sees nothing. This seeing eye sees itself blind. *On the other hand [d'autre part],* and this would be, as it were, the eye's nocturnal truth, the *other* eye is already plunged into the night, sometimes just barely hidden, veiled, withdrawn *[en retrait],* sometimes totally indiscernible and dissolved into a blotch, and sometimes absorbed by the shadow cast upon it by a top hat shaped like an eyeshade. From one blindness, the other. At the moment of the autograph, and with the most intense lucidity, the seeing blind man observes himself and has others observe . . .

— You are always saying observe, to have others observe, etc. You like this word . . .

21. Henri Fantin-Latour, *Self-Portrait,* Louvre Museum, Orsay Museum Collection.

22. Henri Fantin-Latour, *Self-Portrait,* Louvre Museum, Orsay Museum Collection.

24. Henri Fantin-Latour, *Self-Portrait,* Louvre Museum, Orsay Museum Collection.

23. Henri Fantin-Latour, *Self-Portrait,* Denver, The Denver Art Museum.

25. Henri Fantin-Latour, *Self-Portrait,* Louvre Museum, Orsay Museum Collection.

26. Henri Fantin-Latour, *Self-Portrait,* Louvre Museum, Orsay Museum Collection.

27. Henri Fantin-Latour, *Self-Portrait,* Louvre Museum, Orsay Museum Collection.

— Yes, it associates scopic attention with respect, with deference, with the attention of a gaze or look that also knows how to look after, with the contemplative gathering of a memory that conserves or keeps in reserve. Here, the signatory, who is also the model, the object or the subject of the self-portrait, thus has us observe that he is looking at himself seeing the model that he himself is in a mirror whose image he is letting us see: a drawing of the blind that, in two different takes, in white and in black, shows itself drawing. He shows this movement, this touching or examination, with the assured gesture of a surgeon. But a surgeon who does not look at his hands any more than a blind man does. He turns his eyes neither towards what he holds between his hands, the vertical or oblique point of a scalpel, staff, or pencil, nor towards what lies beneath his hands, the body, the scarified skin, the ground or surface of inscription.

We are getting to what at the outset I called the *hypothesis of sight*—or the intuitive hypothesis, the *hypothesis of intuition*. One generally dissociates conjecture from perception. One even opposes hypothesis to intuition, to the immediacy of the "I see" *(video, intueor),* "I look at" *(aspicio),* I "have an eye on" *[je mire],* I am astonished to see, I admire *(miror, admiror)*. And so right here, and this is a paradigm, we can only *suppose* intuition. In fact, in these last two cases (a self-portrait of the draftsman drawing and *seen full face*), it is only *by hypothesis* that we imagined him in the process of drawing himself facing a mirror, and thus doing the self-portrait of the draftsman doing the self-portrait of the draftsman. But this is only *conjecture;* Fantin-Latour might also be showing himself in the process of drawing *something else (Self-Portrait of the Artist Drawing)*. He might be drawing himself full face, facing something else or facing us, but not necessarily facing himself, just as others draw themselves in profile; thus we have *The Painter Drawing* (in the manner of Bruegel the Elder) or **29** Van Rysselberghe's seated draftsman, whom one might identify with the **28** painter, at least by metonymy, but about whom one might also learn, through necessarily external indications, that he is another artist (in this case, Charpentier).

What does this conjecture bring to light? In order to form the hypothesis of the self-portrait of the draftsman as self-portraitist, *and seen full face,* we, as spectators or interpreters, must imagine that the draftsman is staring at one point, at one point only, the focal point of a mirror that is *facing* him; he is staring, therefore, from the place that *we* occupy, in a face to face with him: this can be the self-portrait of a self-portrait only *for the*

28. Théo Van Rysselberghe, *The Sculptor Alexandre Charpentier in front of his Easel,* Louvre Museum, Orsay Museum Collection.

29. In the manner of Pieter Bruegel, *Pieter Bruegel in his Studio,* Louvre Museum.

other, for a spectator who occupies the place of a single focal point, but in the center of what should be a mirror. The spectator replaces and then obscures the mirror, he makes one blind to the mirror by producing, *by putting to work,* the sought after specularity. The spectator's performance, as it is essentially prescribed by the work, consists in striking the signatory blind, and thus in gouging out—*at the same stroke*—the eyes of the model, or else in making him, the *subject* (at once model, signatory, and object of the work), gouge out his own eyes in order both to see and to represent himself at work. *If there were such a thing,* the self-portrait would first consist in assigning, thus in describing, a place to the spectator, to the visitor, to the one whose seeing blinds; it would assign or describe this place following the gaze of a draftsman who, *on the one hand,* no longer sees himself, the mirror being necessarily replaced by the destinatory who faces him, that is, by us, but us who, *on the other hand,* at the very moment when we are instituted as spectators *in (the) place of the mirror,* no longer see the *author* as such, can no longer in any case identify the object, the subject, and the signatory of the self-portrait of the artist as a self-portraitist. In this self-portrait of a self-portrait, the figure or face of Fantin-Latour should be looking at us looking at him according to the law of an impossible and blinding reflexivity. In order to see himself or show himself, he should see only his two eyes, his own eyes—two eyes that he must, however, get over mourning just as soon, and precisely in order to see himself, eyes that he must just as soon replace, to this end, with this representation in sight, and in (the) place of the mirror, by other eyes, by eyes that see him, by our eyes. We are the condition of his sight, certainly, and of his own image, but it is also the case, as in Hoffmann's "The Sandman,"[59] that we rub out his eyes in order instantly to replace them: we are

59. E. T. A. Hoffmann, "The Sandman," in *Tales,* trans. L. J. Kent and E. C. Knight (New York: Continuum, 1982), 277–308. Hoffmann's tale is a frightening story of torn out eyes and optical prostheses. The children's nurse describes a wicked man who throws handfuls of sand into the eyes of children who refuse to sleep, making their bleeding eyes pop out of their heads. During a delirious illness, the student Nathanael associates the terrible face of the lawyer Coppelius (whom he would have heard shouting, "Give me eyes, Give me eyes!") with that of the itinerant optician, Coppola, who, while yelling in the streets, "I gotta da eyes too. I gotta da nice eyes," in fact sells only harmless eyeglasses. Nathanael buys a pocket spyglass to spy on the beautiful Olympia, Professor Spalanzini's daughter, who turns out to be an automaton. Then comes the scene where Coppola and Spalanzini fight over the eyeless doll. Spalanzini flings Olympia's bloody eyes at the student's head, screaming that Coppola has stolen them, etc. The end of the illness and delirium is not the end of the narrative—the end of a narrative that the Freudian literature has, perhaps unfortunately, saturated with automatic interpretations. It is in "The 'Uncanny'" (1919) that Freud, in any case, illustrates with a reference to "The Sandman" his most eye-striking

his eyes or the double of his eyes. A bottomless debt, a terrifying prosthesis, and one can always detect this fear in the draftsman's gaze, though the hypothesis is just as petrifying *[médusante]* for us as for him.

This is not only the hypothesis of the specular or of the imaginary duel. For a mirror is also necessarily inscribed in the structure of self-portraits of draftsmen drawing *something else.* But in this case, one must suppose, in addition to the mirror, *another object,* one that does not look, an eyeless, abocular object, or at least (since it may be a third being supplied with eyes or an optical apparatus) an object that, from its standpoint, its place, takes nothing into consideration, has no views. Only the topic of an abocular object, only this topical remedy, rescues Narcissus from blindness. And this to infinity, since there is no object, as such, without a supposed spectator: the hypothesis of sight.

Again—once again—one must observe the differences: this time between the portraits of *another* draftsman drawing something *else* (though these allograms are in every case figures of self-portraits) and the self-portrait of the author as a draftsman *drawing something else.* Facing the easel, close up to it, is this Van Rysselberghe or his model, Charpentier, himself like another draftsman, seated, glasses on his nose, his eyelids lowered, holding a cigarette in the fingers of his left hand, which rests on his

28

formulation of the equivalence between anxiety over one's eyes and the castration complex; it is there that we find his discourse on the genesis of doubles, the effects of primary narcissicism, etc. Crime, punishment, blindness. At the center of it all is the figure of Oedipus: "The self-blinding of the mythical criminal, Oedipus, was simply a mitigated form of the punishment of castration—the only punishment that was adequate for him by the *lex talionis. . . .* Moreover, I would not recommend any opponent of the psychoanalytic view to select this particular story of the Sandman with which to support his argument that anxiety about the eyes has nothing to do with the castration complex. For why does Hoffmann bring the anxiety about the eyes into such intimate connection with the father's death? And why does the Sandman always appear as a disturber of love?" (trans. James Strachey, in *The Standard Edition of the Complete Psychological Works of Sigmund Freud* [London: Hogarth Press, 1955], 17:231).

Among other texts, one might also look at the nice mythological examples of the repression of sexual scoptophilia in "The Psychoanalytic View of Psychogenic Disturbance of Vision" (Freud, *The Standard Edition,* 1955), 11:209–18. Concerning the logic of the Freudian reading on this point and certain of the questions it raises, permit me to refer to *Dissemination,* trans. Barbara Johnson (Chicago: University of Chicago Press, 1981), esp. 268ff., n. 67. See in particular Sarah Kofman's analysis "The Double is/and the Devil," in *Freud and Fiction,* trans. Sarah Wykes (Cambridge, England: Polity Press, 1991). Besides "the impasses of a thematic reading" (128ff.), the question of "voyeurism," among other things, is here developed out of the example of "The Sandman." "The fear of losing one's eyes is thus related to the fear of castration, but it is derived more directly from the *lex talionis:* it is related to a crime where the eyes are the source of guilt: 'if you have sinned with your eyes it is by your eyes that you will be punished'" (151ff.).

bent back leg, while with his right hand he *is quite visibly drawing, right now,* this thing over which he is leaning but which is *also hidden from our sight?* Facing the easel, but with the marked distance of a step back, is it really the author *himself* (of whom should we say *himself* in this case?) of this "*Painter Drawing*" (in the manner of Bruegel the Elder)? He is stand- **29** ing this time without glasses, his eyelids raised, holding a palette between the fingers of his left hand, his arm folded across his chest, while with the long stick poised in his right hand he *is visibly not drawing* but looking, with a painter's eyes and from a suitable distance, at the drawing's *linea ducta,* which, this time, *we see and read* beneath his feet, or more precisely, beneath his signature. And this signature is also the signature of another, a signature whose lines mime the rhythm of the whole scene, which is itself reflected and displaced, reassembled in a corner: the student of the master, *humble,* that is, close to the ground,* seated cross-legged, visibly drawing, *in the manner* of the master, this thing over which he is leaning but which is *also hidden from our sight.*

One should once again differentiate the sketch of this typology. Yet in all the cases of the self-portrait, only a nonvisible referent in the picture, only an extrinsic clue, will allow an identification. For the identification will always remain indirect. One will always be able to dissociate the "signatory" from the "subject" of the self-portrait. Whether it be a question of the identity of the object drawn by the draftsman or of the draftsman who is himself drawn, be he the author of the drawing or not, the identification remains *probable,* that is, uncertain, withdrawn from any internal reading, an object of inference and not of perception. An object of culture and not of immediate or natural intuition. (One might here locate, in all rigor, the condition for a sociology of the graphic art and for a pedagogy of the gaze.) This is why the status of the self-portrait of the self-portraitist will always retain a hypothetical character. It always depends on the juridical effect of the title, on this verbal event that does not belong to the inside of the work but only to its parergonal border. The juridical effect calls the third to witness, calls on him to give his word, calls upon his memory more than upon his perception. Like Memoirs, the Self-Portrait always appears in the reverberation of several voices. And the voice of the other orders or commands, makes the portrait resound, calls it without symmetry or consonance.

*The word "humble," it should be recalled, comes from the Latin *humus,* meaning soil or earth. —Trans.

If what is called a self-portrait depends on the fact that it is called "self-portrait," an act of naming should allow or *entitle* me to call just about anything a self-portrait, not only any drawing ("portrait" or not) but anything that happens to me, anything by which I can be affected or let myself be affected. Like Nobody, like nobody else,* as Odysseus will say as he is about to blind Polyphemus. Before even attempting a systematic history of the portrait, before even diagnosing its decline or ruin ("the portrait is in a state of collapse," Valéry said),[60] one must always say of the self-portrait: "if there were such a thing . . . ," "if there remained anything of it." It is like a ruin that does not come *after* the work but remains produced, *already from the origin,* by the advent and structure of the work. In the beginning, at the origin, there was ruin. At the origin comes ruin; ruin comes to the origin, it is what first comes and happens to the origin, in the beginning. With no promise of restoration. This dimension of the ruinous simulacrum has never threatened—quite to the contrary—the emergence of a work. It's just that one must know [*savoir*], and so *one just has to see* (it) [*voir ça*] †—i.e., that the performative fiction that engages the spectator in the signature of the work is given to be seen only *through* the blindness that it produces as its truth. As if glimpsed through a blind. Even if one were sure that Fantin-Latour were drawing himself drawing, one would never know, *observing the work alone,* whether he were showing himself drawing *himself* or *something else*—or even himself *as something else, as other.* And he can always, in addition, draw this situation: the stealing away of what regards you, of what looks at you, of what fixedly observes you not seeing that with which or with whom you are dealing. Does the signatory himself see that which he makes you observe? Will he have seen it in some present?

Fantin ventured to say of himself: "He is a model who is always ready; he offers every advantage: he is punctual, submissive, and one knows him before painting him."[61] Is this a stupefying or a stupefied tranquility? The superb irony of the portraitist as a model? The one, the other, knows at

*The phrase here is *comme personne,* which at once assigns an identity, "like nobody else," and takes it away, "like nobody." In the French version of the *Odyssey* to which Derrida refers, Odysseus is called *Personne.* —Trans.

† *Voir ça,* "to see it," is an inverted homonym of *sa-voir,* "to know." —Trans.

60. Cited in Michel Servière's study, "L'imaginaire signé," in *Portrait, autoportrait,* E. Van de Casteele, J. L. Déotte, M. Servière (Paris, 1987), 100ff. On this point, I also refer to Louis Marin's analysis, "Variations sur un portrait absent: les autoportraits de Poussin (1649–1650)," in *Corps écrit,* no. 5.

61. Cited by L. Bénédite, Preface to the Exhibition of 1906.

30. François Stella, *Ruins of the Coliseum in Rome,* Louvre Museum.

32. Cigoli, *Study of Narcissus,* Louvre Museum.

31. Cigoli, *Narcissus,* Louvre Museum.

least one thing: that he would never know how to be accessible as such, and especially not to knowledge, neither beforehand nor after. All symmetry is interrupted between him and himself, between him, the spectacle, and the spectator who he also is. There are now only specters. In order to get out of this, it is necessary, at the very least, to share out the roles in the heteroportrait, indeed in sexual difference. Thus Picasso to Gertrude Stein: "When I see you, I do not see you." And she: "And as for me, I finally see myself."

As soon as the draftsman considers himself, fascinated, fixed on the image, yet disappearing before his own eyes into the abyss, the movement by which he tries desperately to recapture himself is already, in its very present, an act of memory. Baudelaire suggested in *Mnemonic Art* that the setting to work of memory is not *in the service* of drawing. But neither does it lead drawing as its master or its death. It is the very operation of drawing, and precisely its *setting to work.* The failure to recapture the presence of the gaze outside of the abyss into which it is sinking is not an accident or weakness; it illustrates or rather figures the very chance of the work, the specter of the invisible that the work lets be seen without ever presenting. Just as memory does not here restore a past (once) present, so the ruin of the face—and of the face looked in the face in drawing—does not indicate aging, wearing away, anticipated decomposition, or this being eaten away by time—something about which the portrait often betrays an apprehension. The ruin does not supervene like an accident upon a monument that was intact only yesterday. In the beginning there is ruin. Ruin is that which happens to the image from the moment of the first gaze. Ruin is the self-portrait, this face looked at in the face as the memory of itself, what *remains* or *returns* as a specter from the moment one first looks at oneself and a figuration is eclipsed. The figure, the face, then sees its visibility being eaten away; it loses its integrity without disintegrating. For the incompleteness of the visible monument comes from the eclipsing structure of the *trait,* from a structure that is only remarked, pointed out, impotent or incapable of being reflected in the shadow of the self-portrait. **30** So many reversible propositions. For one can just as well read the pictures of ruins as the figures of a portrait, indeed, of a self-portrait.

Whence the love of ruins. And the fact that the scopic pulsion, voyeur- **31, 32** ism itself, is always on the lookout for the originary ruin. A narcissistic melancholy, a memory—in mourning—of love itself. How to love anything other than the possibility of ruin? Than an impossible totality? Love is as old as this ageless ruin—at once originary, an infant even, and already

old. Love doles out his *traits;* he sights, he comes on site, and sees without seeing—this blindfolded love, "this old child, blind archer, and naked," as Du Bellay says of Cupid.[62] The ruin is not in front of us; it is neither a spectacle nor a love object. It is experience itself: neither the abandoned yet still monumental fragment of a totality, nor, as Benjamin thought, simply a theme of baroque culture.[63] It is precisely not a theme, for it ruins the theme, the position, the presentation or representation of anything and everything. Ruin is, rather, this memory open like an eye, or like the hole in a bone socket that lets you see without showing you anything *at all,* anything *of the all.* This, *for* showing you *nothing at all, nothing of the all.* "For" means here both *because* the ruin shows *nothing at all* and *with a view to* showing *nothing of the all.* There is nothing of the totality that is not immediately opened, pierced, or bored through: the mask of this impossible self-portrait whose signatory sees himself disappearing before his own eyes the more he tries desperately to recapture himself in it. Thoughtful memory and ruin of what is in advance past, mourning and melancholy, the specter of the instant *(stigmē)* and of the stylus, whose very point would like to touch the blind point of a gaze that looks itself in the eyes and is not far from sinking into those eyes, right up to the point of losing its sight through an excess of lucidity. An *Augenblick* without duration, "during" which, however, the draftsman feigns to stare at the center of the blind spot. Even if nothing happens, if no event takes place, the signatory blinds himself to the rest of the world. But unable to see himself properly and directly—a blind spot or transcendental *trait*—he also blindly contemplates himself, attacks his sight right up to the exhaustion of narcissism. The truth of his own eyes as seer, in the double sense of this word, is the last thing that can be taken by surprise—*naked,* without attribute, without glasses, without a hat, without a blindfold on the head, in a mirror. The naked face cannot look itself in the face, *it cannot look at itself in a looking glass.*

This last locution says something about the shame or modesty that is part of the picture. It engages the picture in the irrepressible movement of a confession. Even if there is as yet no crime (whether a reality or a phantasm), even if there is no Gorgon, no mirror-shield, no aggressive or apo-

62. Joachim Du Bellay, *L'olive* (Geneva: Droz, 1974), sonnet 26.
63. Benjamin speaks of "the baroque cult of the ruin": "that which lies here in ruins, the highly significant fragment, the remnant, is, in fact, the finest material in baroque creation" (*The Origin of German Tragic Drama,* trans. John Osborne [New York: Verso, 1977], 178).

tropaic gesture. Shame or modesty, to be sure, which is barely overcome in order to be observed, looked after and looked at, respected and kept at a respectful distance, its status that of a shade. Yet there is also fear given over to spectacle, the seeing-oneself-seen-without-being-seen, histrionics and curiosity, exhibitionism and voyeurism: the subject of the self-portrait becomes fear, *it makes itself into fear, makes itself afraid.*

But because the other, over there, remains irreducible, because he resists all interiorization, subjectification, idealization in a work of mourning, the ruse of narcissism never comes to an end. What one cannot see one can still attempt to reappropriate, to calculate the interest, the benefit, the usury.* One can describe it, write it, stage it.

On the one hand, one will draw the artifact: technical objects designed, **37, 38** like prostheses, to supplement sight and, first of all, to compensate for this transcendental ruin of the eye that threatens and seduces it from the origin; for example, mirrors, telescopes, glasses, binoculars, monocles. But because the loss of direct intuition, as we have seen, is the very condition or hypothesis of the gaze, the technical prosthesis takes place, takes its place, before all instrumentalization, as close as possible to the eye, like a lens made of animal matter. It immediately *stands out,* is immediately *detachable* from the body proper. The eye is detachable,[64] and it catches the eye: one can desire it, desire to tear it out, to tear each other to pieces over it. And this from the very beginning: the modern history of optics only represents or points out in new ways a weakness of what is called natural sight; beginning with what are called *spectacles* in English, as we noted only a moment ago, the draftsman's eyeglasses. Whence the self-portraits with eyeglasses. Chardin's self-portrait, known as *Self-Portrait with Eyeshade,* **34** bespeaks well the eyeshade, since it plunges the painter's eyes into the shade, or protects them within it. (Like that other detachable fetish, the hat, whose brim almost hides Fantin-Latour's eyes in a self-portrait.) And **23** in addition, every bit as jealously, every bit as blindly [*jalousement*], it at once shelters and shows the same eyes behind a pair of eyeglasses whose

*For Derrida's notion of *usure* as both "usury, the acquisition of too much interest, and using up, deterioration through usage," see the translator's note in "White Mythology," in *Margins of Philosophy,* trans. Alan Bass (Chicago: University of Chicago Press, 1982), 209. —Trans.

64. On the theme of the "detachable," and, in particular, on what links it to the supplement, the prosthesis, and the "parergon," permit me once again to refer to *Glas,* trans. John P. Leavey, Jr., and Richard Rand (Lincoln: University of Nebraska Press, 1986) and *The Truth in Painting,* trans. Geoff Bennington and Ian McLeod (Chicago: University of Chicago Press, 1987).

33. Gavarni, *Two Pierrots Looking into a Box,* Louvre Museum.

stems are visible. The painter seems to be posing face-front, he is facing you, inactive and immobile. In the *Self-Portrait with Spectacles* (glasses without stems, a pince-nez for working perhaps), Chardin lets himself be seen or observed in profile; he appears more active, momentarily interrupted perhaps, turning his eyes away from the picture. But in another self-portrait he represents himself in the process of painting or drawing, the hand and the instrument visible at the edge of the canvas. In this respect, one can always consider this self-portrait as one example among others in the series of Chardin's *Draftsmen.*[65] Is he busy about the self-portrait or about something else, another model? One would not know how to decide. In all three cases, the glasses are on and a bandanna is wrapped around the head; the eyes are not blindfolded *[bandés]* this time but the head is bandaged up *[bandée],* a word that can always suggest, among other things, a wound: right on the face to which they do not belong, detachable from the body proper like fetishes, the bandanna and the spectacles remain the illustrious and most exhibited supplements of these self-portraits. They distract as much as they concentrate. The face does not show itself naked, especially not that; and this, of course, unmasks nakedness itself. This is what is called showing oneself naked, showing nakedness—a nakedness that is nothing without modesty, the art of the veil, the window pane, or the piece of clothing.

One can also, *on the other hand,* surprise that which does not let itself be surprised; one can draw the eyes closed: in an ecstatic vision, in prayer or sleep,[66] in the mask of the dead or wounded man. (Look at the eyes of Courbet's *Self-Portrait* known as *The Wounded Man* [1854].)[67]

— Would you say then that the autograph of the drawing always shows a mask?

— Yes, provided that we recall all the values of the mask. *First,* dissimulation: the mask dissimulates everything *save* (whence the blind and jealous fascination it exercises) the naked eyes, the only part of the face at

65. *A Draftsman After the Mercury of M. Pigalle,* Salon of 1753, engraved by Le Bas. *The Draftsman After Chardin,* Salon of 1759, engraved by Flipart. See Michael Fried, *Absorption,* 13–15.
66. For example, Joseph-Marie Vien's *Sleeping Hermit,* Salon of 1753; see also Michael Fried, *Absorption,* 28.
67. See Michael Fried's analysis in the chapter, "The Early Self-Portraits," in *Courbet's Realism* (Chicago: University of Chicago Press, 1990), 53ff.

once seeable, therefore, and seeing, the only sign of living nakedness that one believes to be shielded or exempt from *[soustrait]* old age and ruin. *Next,* death: every mask announces the mortuary mask, always taking part in both sculpture and drawing. *Finally (as a result,* and this quasi-transcendental deduction has no need of myth, event, or proper name), the "Medusa" effect: the mask shows the eyes in a carved face that one cannot look in the face without coming face to face with a petrified objectivity, with death or blindness.

Each time one wears a mask, each time one shows or draws a mask, one repeats Perseus's heroic deed. At one's own risk or peril. Perseus could become the patron of all portraitists. He signs every mask. "Each time," we said, each time a mask is worn on the face or held by hand, each time it is shown, exhibited, objectified, or designated, it is Perseus who is put to the test of drawing. Consequently, the story of this heroic son does not only give rise to the narrative of an event. The myth also illustrates or rather figures an index, the finger of a draftsman or the *trait* of a structure. Without directly facing the fatal gaze of Medusa,[68] facing only its reflection **44** in the bronze shield polished like a mirror, Perseus sees without being **47** seen. He looks to the side when he decapitates the monster and when he exhibits her head to his enemies in order to make them flee with the threat of being petrified. Here again, there is no direct intuition, only angles and **46, 45** the obliqueness of the gaze. Let us not forget that all these, once again, are scenes of prediction and filiation, scenes of the seer. The oracle had announced to Danaë that if she had a son he would kill his grandfather. This latter, Acrisius, king of Argos, had his daughter locked up, but Zeus turned himself into golden rain in order to *visit* her. The resulting birth is thus heroic, half-divine, half-human—like Dionysus'. Dionysus, whom Perseus hates, and whose father—their common father—had shown himself as such, *for once,* at the moment of coupling. To sever the Medusa's head following Polydectes' challenge, the hero has to multiply the steps or

68. "To decapitate = to castrate. The terror of Medusa is thus a terror of castration that is linked to the sight of something. . . . The sight of Medusa's head makes the spectator stiff with terror, turns him to stone. Observe that we have here once again the same origin from the castration complex and the same transformation of affect! For becoming stiff *(das Starrwerden)* means an erection. Thus in the original situation it offers consolation to the spectator: he is still in possession of a penis, and the stiffening reassures him of the fact." Freud, "Medusa's Head," translated under the general editorship of James Strachey, in *The Standard Edition of the Complete Psychological Works of Sigmund Freud* (London, 1955), 18:273. (I translated part of this text and proposed a reading of it in *Dissemination,* 39ff.,
(continued on p. 87)

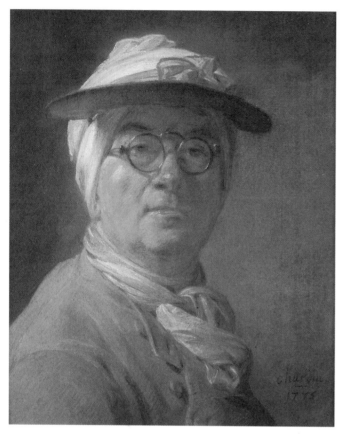

34. Jean-Baptiste Siméon Chardin, *Self-Portrait with Eyeshade,* Louvre Museum.

35. Jean-Baptiste Siméon Chardin, *Self-Portrait with Spectacles,* Louvre Museum.

36. Jean-Baptiste Siméon Chardin, *Self-Portrait at the Easel,* Louvre Museum.

37. Félicien Rops, *Woman with Monocle,* Louvre Museum, Orsay Museum Collection.

38. Pisanello, *Study of Three Heads,* Louvre Museum.

39. Odilon Redon, *With Closed Eyes,* Louvre Museum, Orsay Museum Collection.

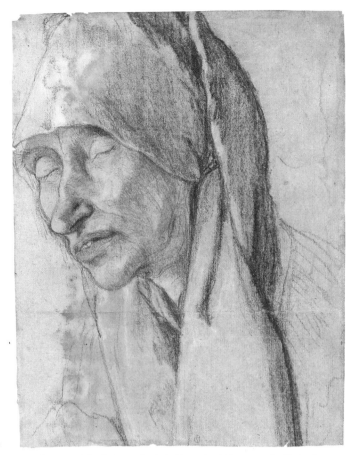

41. German School (around 1540), *Portrait of Margarete Prellwitz,* Louvre Museum.

40. Bernard de Ryckere, *Head of a Dying Man,* Louvre Museum.

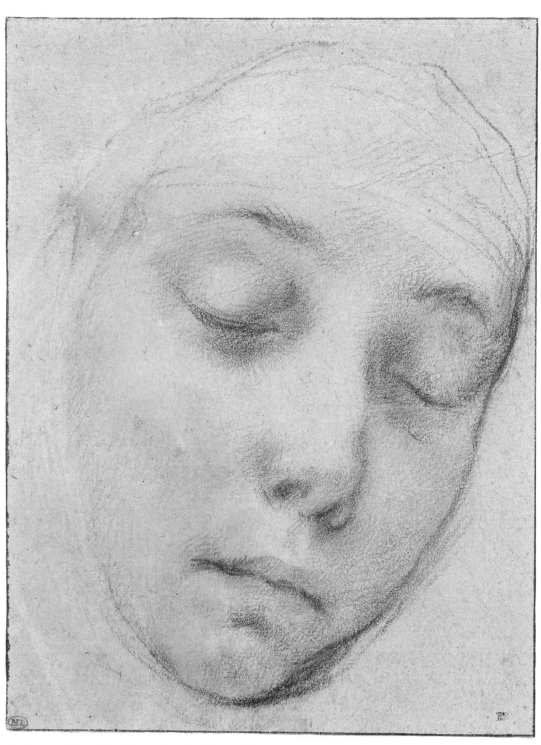

42. Francesco Vanni, *The Blessed Pasitea Crogi,* Louvre Museum.

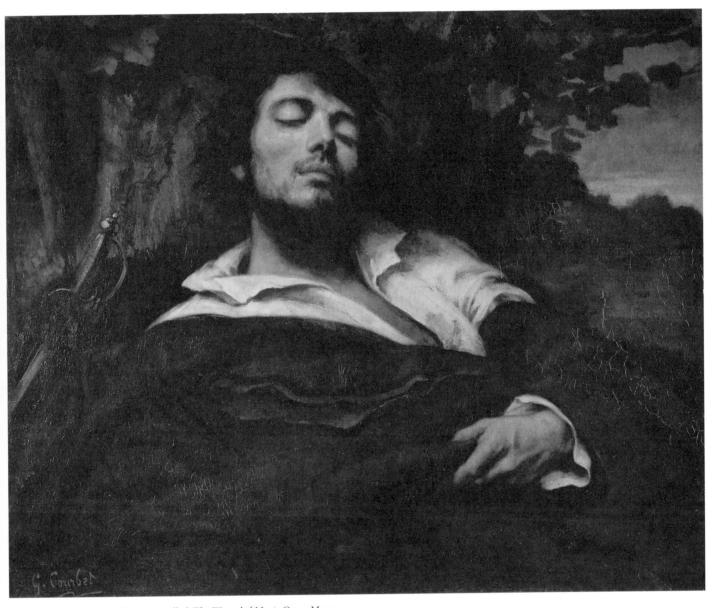

43. Gustave Courbet, *Self-Portrait* (called *The Wounded Man*), Orsay Museum.

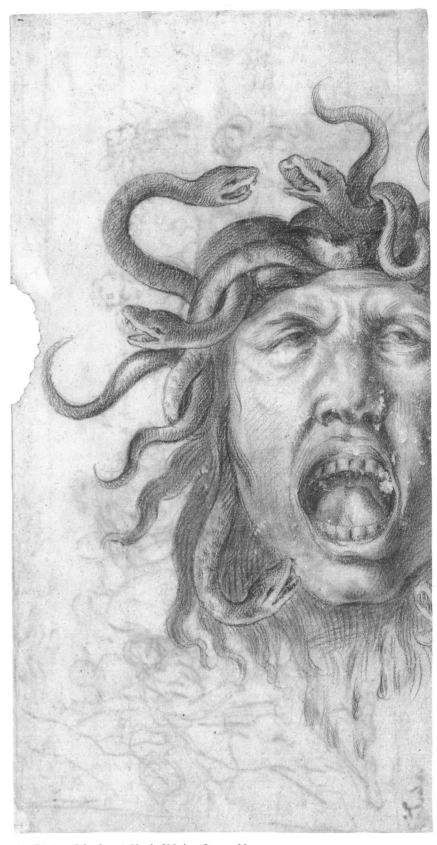

44. Giacinto Calandrucci, *Head of Medusa,* Louvre Museum.

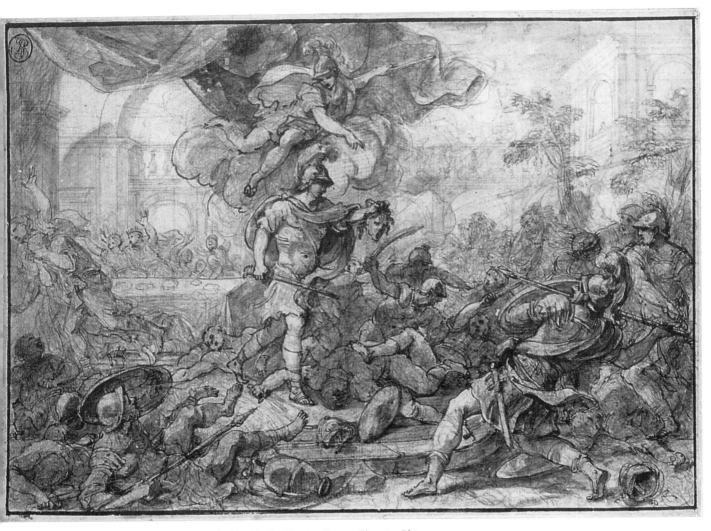

5. Seventeenth-century Neapolitan School, reworked by Charles Natoire, *Perseus Changing Phineus into Stone,* Louvre Museum.

46. Carel Van Mander, *Perseus Changing Phineus into Stone,* Louvre Museum.

47. Luca Giordano, *Perseus Beheading Medusa,* Louvre Museum.

48. Odilon Redon, *The Eye with Poppy,* Louvre Museum, Orsay Museum Collection.

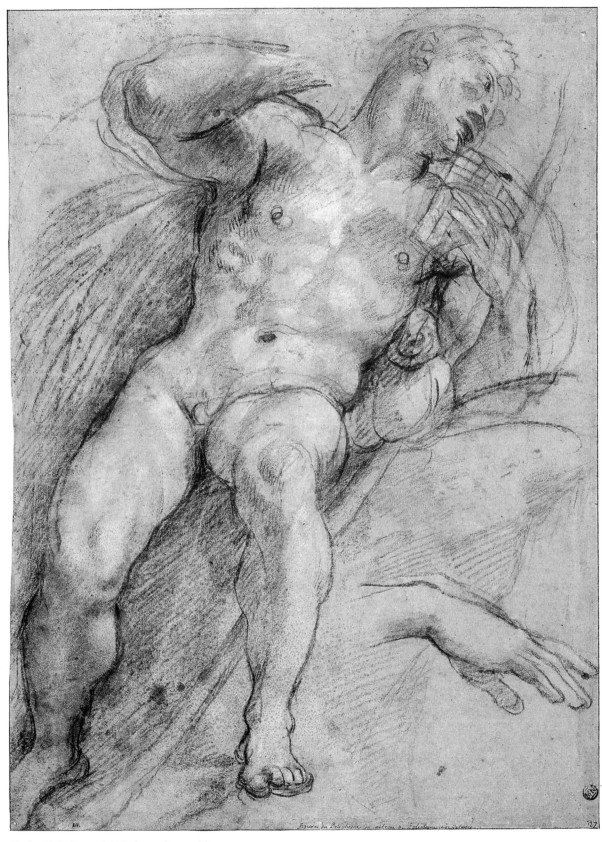

49. Annibale Carracci, *Polyphemus,* Louvre Museum.

tasks, and each time it is a story of the eye. He must receive from the Nymphs the helmet of Hades, the *kunē* that renders one invisible. But in his search for the Nymphs, he first pays a visit to *[se rend chez]* the female elders, the Graiae, sisters of the Gorgons. Between the three of them they have but one eye and a single tooth. One of them stays on the lookout, keeping the eye always open, the tooth ready to devour. Perseus steals this eye and tooth during the changing of the guards, as it were, at the moment when they are passed from one hand to another and thus belong to no one. He thus steals a sort of subjectless vigilance. (Once again, the lone, unique eye *stands out, is detachable;* it circulates between subjects like an instrumental organ, a fetishized prosthesis, an object of delegation or representation. Moreover, by making it into a partial object, all the representations of an eye dissociated or worked over by a graft are inscribed in this scene. This is as much the case in all anatomical and "objective" representations of the eye as it is, for example, in Odilon Redon's *The Eye with* **48** *Poppy.*) After having severed the head of Medusa, after having hidden in his bag this potential for death that fascinates and redoubles the gaze of the other, leading to its perdition, Perseus escapes from the other Gorgons, thanks to the helmet of invisibility.

Each time, then, there is the ruse of an oblique or indirect gaze. A ruse that consists in sidestepping rather than meeting head-on the death that comes through the eyes. Death threatens sometimes by the specular crossing of gazes (Perseus thus plays one mirror off another, looking at Medusa in a mirror so as not to cross her gaze), sometimes by the unicity of a staring eye, by a sleepless vigilance, but also by the missing eye or the eye-too-many, the expropriable eye that can be stolen, borrowed with usury, the eye that must not be seen, or the eye open like a wound, indeed gaping like an open mouth whose eyelid-lips might also open up, in order to expose it, onto a woman's sex. It would be difficult not to associate the Graiae with the Cyclops. The story of Polyphemus is both that of a Cy- **49** clops, thus of a monster, half-beast, half-god, the son of Poseidon who is in love with Galatea, and that of a giant made drunk and then put to sleep by the ruse of Odysseus, who then drives a fire-hardened stake into his eye: a *single, unique* eye, a *closed* eye, an eye *gouged out.* By ruse rather than by force *(dolō oude biēphin),* and by someone who calls himself "No-

n. 39.) On the Gorgon and the myth of Perseus, I refer you to Jean-Pierre Vernant, especially to the chapter, *"La mort dans les yeux,"* in the book of the same title (Paris, 1985).

body."[69] The *mētis* of *Outis*: the deception that blinds is the ruse of *nobody (outis, mē tis, mētis);* Homer plays more than once on these words when Polyphemus echoes the question of the chorus: *(ē mē tis . . . ē mē tis . . .):* "Ruse, my friends! Ruse and not force! . . . and who is killing me? Nobody!"* And Odysseus, in turn, echoes back the same words by signing his ruse with his name of nobody and with his "*mētis.*" By presenting himself as Nobody, he at once names and effaces himself: like nobody, like nobody else—the logic of the self-portrait. And yet the cruel ruse of Nobody does not fail to make a spectacle of its triumph. It is, in our poetic memory, one of the most terrifying descriptions of an eye gouged out. Has it ever been drawn? Has anyone ever represented the movement of this lever, of this *mochlos,* or fiery-pointed stake, as it draws a piercing spiral into Polyphemus' bleeding eye?

> He spoke, and reeling fell upon his back. . . . Then verily I thrust in the stake under the deep ashes until it should grow hot. . . . But when presently that stake of olive wood was about to catch fire, green though it was, and began to glow terribly, then verily I drew nigh, bringing the stake from the fire, and my comrades stood round me and a god breathed into us great courage. They took the stake of olive wood, sharp at the point, and thrust it into his eye, while I, throwing my weight upon it from above, whirled it round, as when a man bores a ship's timber with a drill, while those below keep it spinning with the thong, which they lay hold of by either end, and the drill runs around unceasingly. Even so we took the fiery-pointed stake and whirled it around in his eye, and the blood flowed around the heated thing. And his eyelids wholly and his brows round about did the flame singe as the eyeball burned, and its roots crackled in the fire. [And as when a smith dips a great axe or an adze in cold water amid loud hissing to temper it—for therefrom comes the strength of iron—even so did his eye hiss round the stake of olive wood.][70] Terribly then did he cry aloud, and the rock rang around; and we, seized with terror, shrank back, while he wrenched from his eye the

*There are two ways to say nobody in Greek—*outis* and *mē tis.* The latter, when made into one word, *mētis,* means ruse or cunning. Odysseus calls himself *Outis* in this scene with the Cyclops and, after the blinding, is called *mē tis* by him—the homophony between *mētis* and *mē tis* at once assigning and withdrawing the proper name, as well as the ruse that produces this ambivalence. —Trans.

69. Homer *Odyssey,* trans. A. T. Murray (Cambridge: Loeb, 1938) 9.406–14.

70. We are dealing here with an interpolation. One will observe that it belongs to the language of the sacrificed victim, to what would appear to be the cyclopes' code of metallurgy. As certain drawings show, their rightful place, their proper place, is often the forge.

stake, all befouled with blood, and flung it from him, wildly waving his arms. Then he called aloud to the Cyclopes who dwelt round about him. . . .[71]

Cyclopia is the name of a region near Naples whose first inhabitants were called by the first Greek colonists the *Opikoi* (the Eye-landers) and whose other name was *oinotria,* which the Greeks interpreted as "wine country" *(oinos = vinum).* Talkative and much talked about, as his name might indicate, Polyphemus seems to spit out lava and rock. His drunken clamor embodies volcanic power—the land pockmarked with craters, like so many erupting eyes. (Besides, the cyclopes, these wandering giants who are nonetheless at home at the forge, often belong, as we see here, to the guilds of vulcanites and metallurgist-magicians.)[72] Cyclopia, "Eye-land," unceasingly spews forth tears of fury. The eye of a cyclops gives rise to heterogeneous representations. The description is rarely coldly detached or neutral. An eye, the one-and-only-eye, the monocle, is never an object.

50

71. *Odyssey* 9.370–99. This scene is evoked at the center of the great "Report on the Blind" in Ernesto Sábato's *On Heroes and Tombs,* translated from the Spanish by Helen R. Lane (Boston: David R. Godine, 1981), 360–61. I would like to thank Cristina de Peretti for having given me this to read. I will cite from it only one long passage, and this, because of its conclusion, the one toward which we are headed here, the *conclusion* of closed eyes: a certain passage between belief—the "I believe," "believe," "you believe"—and what we have named the *hypothesis of sight:* "And thus, while the other children hurried through the pages of Homer, finding them a bore and reading them only because they were assigned them by their teachers, I felt my first shudder of terror when the poet describes, with frightening power and almost mechanical precision, with the perversity of a connoisseur and violent, vengeful sadism, the moment when Ulysses and his companions run a red-hot stake through the great eye of the Cyclops and make it boil in its socket. Wasn't Homer himself blind?" And after having evoked Tiresias, Athena, and Oedipus: "Nor could I banish from my mind my intimate conviction, that with time became stronger and stronger and more and more well founded, that the blind rule the world, by way of nightmares and fits of delirium, hallucinations, plagues and witches, soothsayers and birds, serpents, and, in general, all the monsters of darkness and caverns. It was thus that I was little by little able to make out the abominable world that lay behind appearances. And it was thus that I began to train my senses, exacerbating them through passion and anxiety, hope and fear, so as to be able in the end to see the great forces of darkness as the mystics are able one day to see the god of light and goodness. And I, a mystic of Refuse and Hell, can and must say: BELIEVE IN ME!"

72. See Jean-Pierre Vernant, *Myth and Thought Among the Greeks* (Boston: Routledge and Kegan Paul, 1983), 180. Concerning this particular episode, see also Marcel Detienne and Jean-Pierre Vernant, *Cunning Intelligence in Greek Culture and Society,* trans. Janet Lloyd (Atlantic Highlands, N.J.: Humanities Press, 1978), esp. 57–58. If the *Ulysses* of this century was no doubt not the work of a blind man, as the *Odyssey* is said to be, but of a writer destined for blindness, threatened by this privileged fate, it would be necessary to study very closely what is called the Cyclops episode (the tavern in the late afternoon, the

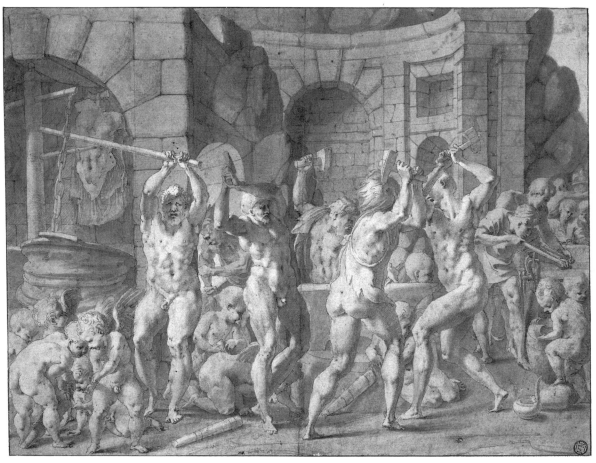

50. Francesco Primaticcio, *Vulcan's Workshop,* Louvre Museum.

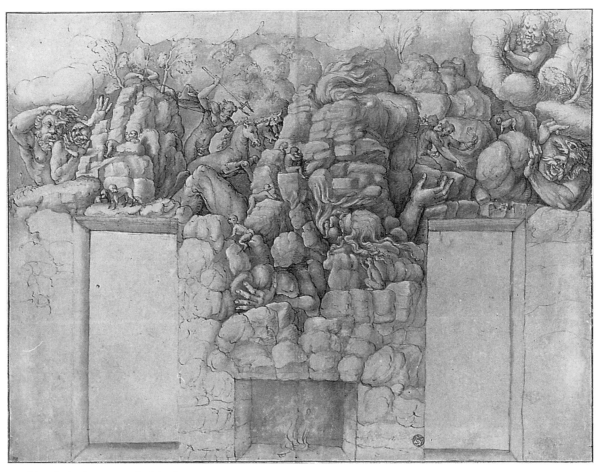

51. After Giulio Romano, *Fall of the Giants,* Louvre Museum.

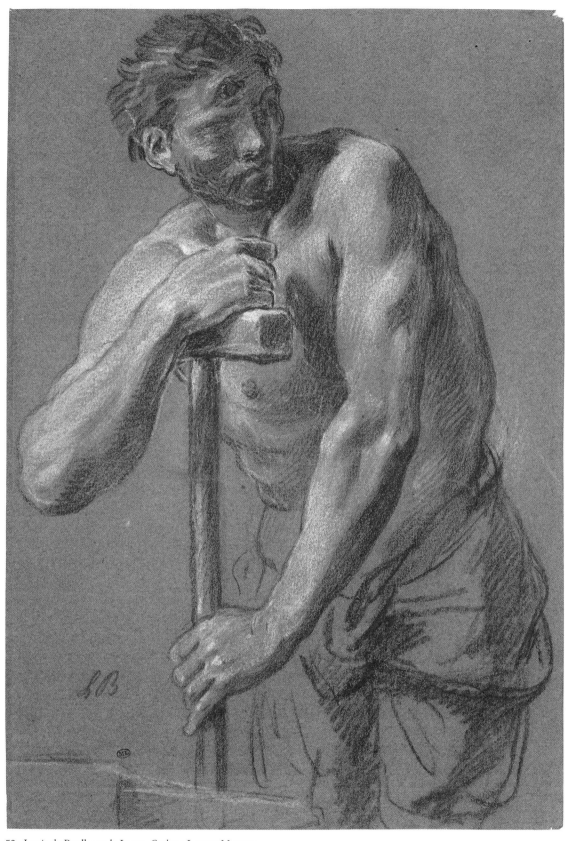

52. Louis de Boullogne le Jeune, *Cyclops,* Louvre Museum.

Sometimes it appears open like a wound whose fleshy lips are still bleeding: the obscenity of a scar, the impossible suture of a slit, frontal genitality. Sometimes the anomaly appears invisible or banalized: a forbidden representation, as was sometimes the case, or a spectacle to avoid, the exhibition of an infirmity, the exposition of a shady or sinister squint. **51**

49, 52

One must add another possibility to this typology: drawing one's own mask in *trompe-l'œil*. Faverjon's *Self-Portrait in Trompe-l'œil* would be exemplary in this regard. The face presumed to be that of the author emerges from *a* frame, but within *the* frame. It overflows the portrait in order to see you looking at what it pretends to show you with an index finger pointing down toward the center, toward this third, open eye whose lid is raised like a theater curtain onto a scene that in turn overflows the eye. This, in the indefinite discharge of the entoptic phantasm or of the fascinated hallucination that can always be interpreted *[interpréter]*—or attributed *[prêter]* to the author. **53**

Let us use this as a pretext to situate a *translation* or a *transfer*. It is also a question of a trembling *hesitation*—just as the hand of the draftsman or the blind man derives its decisive firmness from a groping that is overcome—the hesitation between a *transcendental* and a *sacrificial* thought of the drawing of the blind, a thought of the condition of possibility and a thought of the event. What is important is the hesitation *between the two,* even if it appears to be overcome in the incisive decision, in what makes each of the two thoughts the supplement or the vicar, the stand-in, of the other. For there is neither pure transcendentality nor pure sacrifice. The sacrificial thought seems to appeal more to an event than to a structure. It appears more historical because of this, and the sacrifice always implies some sort of violence (the violence of ruse or deception, the violence of punishment, the violence of conversion and of martyrdom, the blindness that comes from wounded eyes or from bedazzlement), even if what then *happens* or *comes to sight* oscillates between phantasm and the "real." This inflicted violence is always at the origin of the mythic narrative or of the revelation that opens one's eyes and makes one go from the sensible light or the *lumen naturale* to the intelligible or supernatural light. But the event, that which, in this case, happens or comes to sight, also seems to

earthquake, the "seismic waves" that leave behind only a "mass of ruins," of "*débris* human remains," the allusion to the "giant's causeway" and to the "eyewitnesses," etc.). The technique of this chapter is "gigantism," according to Stuart Gilbert, who also insists on the "Elijah motif" at the end of this chapter (*James Joyce's Ulysses* [New York: Vintage Book, 1930], 258ff.).

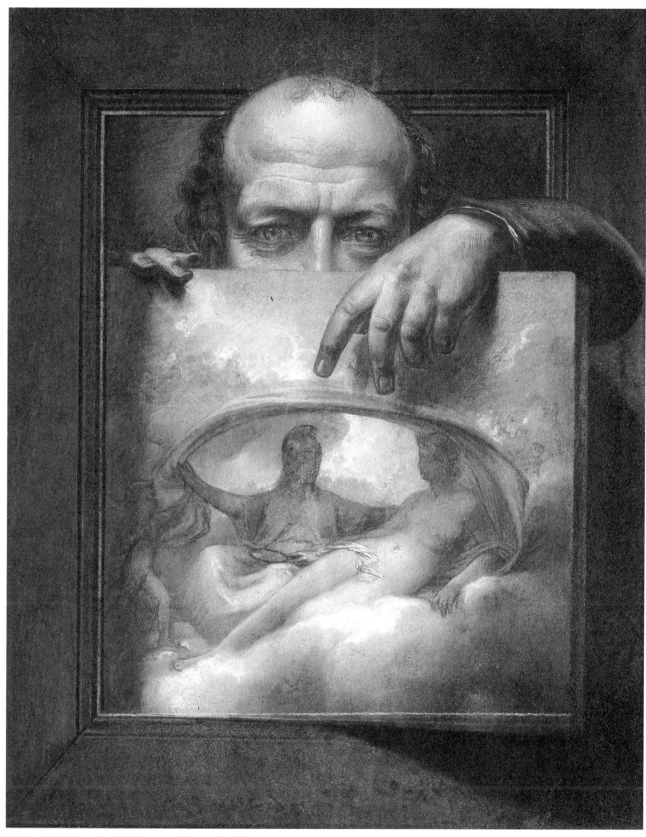

53. Jean-Marie Faverjon, *Self-Portrait in Trompe l'oeil,* Orsay Museum.

annul itself in the structure, which is to say, in the circle of exchange. And that is why this historical logic resembles, and can always substitute for, a transcendental logic that is recalled each time to memory by the *figure* or *species* of the event. Such exchange, as we will see, can take on the *typical*—and always *economic*—forms of the conversion between blindness and the supplement of clairvoyance, indeed, of providence. The blind man can always become a seer or visionary. We could, provisionally, distinguish at least between the three types of violence we just named: *mistaking* (ruse or deception), *punishment,* and *conversion.* Yet the structural logic is powerful or involuted enough to allow these three types to be converted into each other. They exchange themselves, in truth, or take themselves for each other.

The blind man is, first of all, subject to being mistaken, *the subject of mistake.*

Coypel's *The Error,* for example, puts on the scene a man who is blind- **8** folded rather than blind. *He is deceived,* either because he is deceiving himself, almost voluntarily, or because he is being deceived, letting himself be deceived by weakness of will, or else because he is grappling to deceive his own blindness. But as soon as he does not see—and it is through this that he is first and foremost exposed, naked, offered up to the gaze and to the hand, indeed to the manipulations of the other—he is also a subject deceived. The *fall* or the *mistake* lies in wait for him. The other can take advantage of him: in order to make him fall, or in order to substitute one thing for another, making him thus take something for something else. Greuze's *Blind Man Deceived* serves as a paradigm: an old blind man taken **54** advantage of by a young woman. For example (but is this an example among others? my dream of mourning, of elders and eyes, no doubt asked me), can't the same deception put forward one son in the place of another, make one brother pass for the other, at the fateful moment of election or of the testamentary blessing? Isn't the ultimate and irreversible deception, the most monstrous and most tragic—the one that engages a historical destination—the substitution of one child for another at the moment of inheritance? Rebecca makes the old, blind Isaac believe that he is stretch- **58** ing his hand in blessing over Esau, his elder son, though she has in fact substituted Jacob for Esau. Does not the intrigue of the blind man's buff, with all its lightheartedness and childlike playfulness, gesture in this direction—a direction sought after with outstretched arms, as in Fragonard's **55, 56** *Blind Man's Buff* or Bramer's *Scene of the Blind Man's Buff?* Isn't the point **57** to designate a relay by *touching*—as well as *naming*—a successor in the

54. Jean-Baptiste Greuze, *Blind Man Deceived*,
Moscow, Pushkin Museum.

55. Jean-Honoré Fragonard, *Blind Man's Buff,*
Washington, National Gallery of Art.

56. Jean-Honoré Fragonard, *Blind Man's Buff,* detail of the preceding.

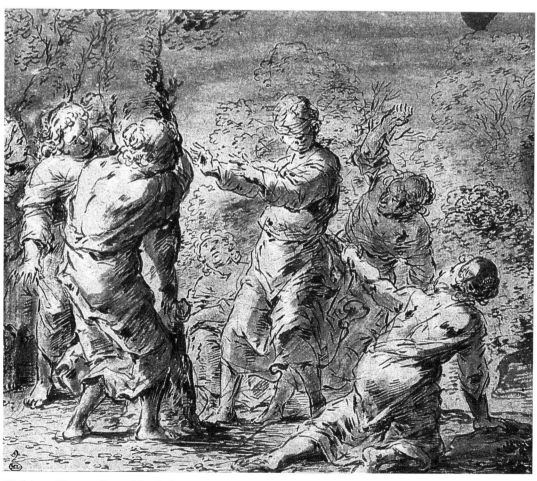

57. Léonard Bramer, *Scene of the Blind Man's Buff,* Louvre Museum.

dark? Isn't it always a question of a play of hands, as in the *Blind Man Deceived,* where Greuze shows the old husband's hand holding his young wife's, as if this contact reaffirmed his confidence and certainty at the very moment when *we* see the two young lovers pulling the wool over his eyes, betraying him but also perhaps about to betray themselves by the fall of the jug?[73]

— I wouldn't swear to it, but that doesn't matter: didn't the paradigm of Jacob being blessed by Isaac also secretly lay the foundation for the scenario of your dream of mourning, of elders and eyes (the old blind men, the threat against sons or brothers), or for the duel with your brother over the power of drawing, the ruse of the younger brother converting his infirmity into a sign of secret election? The hazard or arbitrariness of signifiers, blindfolded Fortune who assigns proper names: your dream distinguishes between two generations; you are younger than the old blind men but you are also the father of the threatened sons—a father whose most visible first name, as you are often reminded, is consonant with Jacob's name as well as Isaac's, beginning with one and ending with the other.

— This blessing of the blind is well known, but the narrative is often butchered. *Two* reversals, which are also repetitions, convert blindness into providential clairvoyance. *In the first place,* it is not a *perfidious* ruse, as is often believed, that pushes Rebecca to deceive the old, blind Isaac by substituting Jacob for Esau. Her ruse anticipates, responds in advance, to the designs of Yahweh, who had announced to her: "Two nations are in

73. Like Greuze's *Blind Man Deceived* (Salon of 1755, Pushkin Museum, Moscow), Fragonard's *Blind Man's Buff* (1755, National Gallery, Washington, D.C.) is reproduced and analyzed from another point of view by Michael Fried (*Absorption,* 67, 141). The *Blind Man Deceived* would allow us to identify a "major shift," right in the middle of the century, in the history of what Fried calls the "absorption" of the "beholder" by the very structure of representation or painting. While the blindness of *The Blind Man* (unknown artist, after Chardin, Salon 1753, reproduced in *Absorption,* 66) "guarantees" by its very indifference that the "figure is unaware of the beholder's presence," the *Blind Man Deceived* (an aged husband, before whom his young wife and her lover try not to make a sound, though the young man "has begun to spill the contents of the jug he carries in his right hand") attracts and involves the beholder. The beholder becomes indispensable to the "narrative-dramatic structure." His place as a visual witness is marked in the workings of the representation. The third, one might say, is included in it. In his rivalry with Chardin, Greuze would have sought *both* "to improve on his great predecessor's invention—to make it all the more resistant to the presence of the beholder," *and* to exploit "the theme of blindness for manifestly" other ends, namely, the inclusion or structural "absorption" of the beholder (*Absorption,* 70).

your womb, and two peoples born of you shall be divided; the one shall be stronger than the other, the elder shall serve the younger."[74] Rebecca sees far ahead, with God's eyes, into the destiny of Israel. And at the moment when the blind old man blesses Jacob, whose hands are covered with the skins of young goats to simulate the hirsute body of Esau, one even wonders whether Isaac himself does not obscurely portend—as if already consenting to it—the unfathomable decision of an invisible God, this God of Abraham, of Isaac, and of Jacob who is never seen face to face and whose ways are secret. Everything takes place between speech and hands.

Now why does Isaac consent to bless a son whose hirsute body he believes he recognizes by touch but whose voice he says he does not recognize? ("So Jacob went up to his father Isaac, who felt him and said, 'The voice is Jacob's voice, but the hands are the hands of Esau.'")[75] Once the deception is discovered, why does Isaac confirm without reservation the blessing that was given? Why does he give Esau the order to serve his brother? *In the second place,* after the dream of the ladder, and after the vision of God, who says to him in a dream—

> I am the Lord, the God of Abraham your father and the God of Isaac; the land on which you lie I will give to you and to your offspring; and your offspring shall be like the dust of the earth, and you shall spread abroad to the west and to the east and to the north and to the south; and all the families of the earth shall be blessed in you and in your offspring. Know that I am with you. . . .[76]

—Why does Jacob himself, *in turn,* become blind, and why does he, *in turn,* bless Ephraim, the younger son of his son Joseph, and not Manasseh, the elder? Why does the old blind man Jacob, having himself become Israel, thereby repeat the substitution through which he was chosen, crossing his hands at the moment of the blessing? How can one choose, which is also to say, sacrifice, a son or a grandson, and why twice? How is blindness capitalized upon the heads of fathers and ancestors? What is the point? What is the interest? Why this usury of the eyes? Why is blindness not only the *effect* of a particular sacrifice (where one loses one's eyes or sight, has them *sacrificed* in the course of or through this *particular* sacrifice—though there are others)? Why is blindness first and foremost the

74. Gen. 25:23.
75. Gen. 27:22.

76. Gen. 28:13–14.

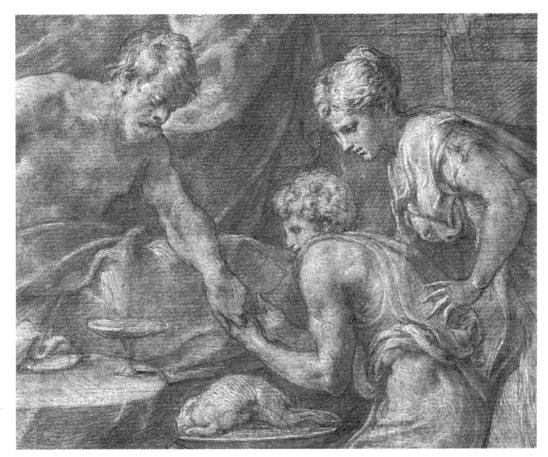

58. Francesco Primaticcio, *Isaac Blessing Jacob,* Louvre Museum.

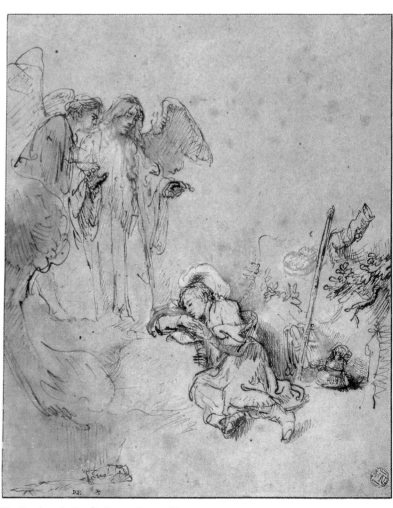

59. Rembrandt, *Jacob's Dream,* Louvre Museum.

very experience of sacrifice in general, this time, from the side of the *sacrificer?* From the side of the sacrificer's hand? In the exergue to his essay on Goethe's *Elective Affinities,* Benjamin quotes Klopstock: "The smoke of sacrifice attacks the eyes of the one who chooses blindly."[77] Why does sacrifice, in its own moment, make one go blind, regardless of what is at stake? And this, whether it be a matter of the act of choosing or of the beings who are chosen—chosen quite often in order to be sacrificed: the only son, the unique son, one son for the other—or the daughter, more invisible than ever. Unless it is the opposite: one no longer sees because one sees too far and too well—but this comes down to the same thing, to the same *hypothesis of sight.* Why *a second time?* Why does this blind man, Jacob, after having himself been chosen or blessed by a blind father, Isaac, why does he in turn invert the natural order of the generations with an eye to obeying divine providence and observing its secret order?

> Now the eyes of Israel were dim with age, and he could not see well. . . . Joseph took them both, Ephraim in his right hand toward Israel's left, and Manasseh in his left hand toward Israel's right, and brought them near him. But Israel stretched out his right hand and laid it on the head of Ephraim, who was the younger, and his left hand on the head of Manasseh, crossing his hands, for Manasseh was the firstborn.[78]

In representing *Jacob's dream,* as Rembrandt, for example, does, one might bring together into the same scene a *vision* (God appearing to Jacob), the *closed eyes of sleep,* and the *clairvoyance of two blind men*—Isaac, then Jacob—this obscure lucidity with which they fulfill divine providence. This providence passes through their hands of the blind. It is inscribed on the inside of these hands, which are guided by the hand of God, as if Yahweh's design were mapped out on the surface of their skin, as if it had, to use an expression of Diderot's, "traced the portrait on the

59

77. "*Wer blind wählet, dem schlägt Opferdampf/In die Augen.*" Walter Benjamin, [Goethe's Elective Affinities] "Goethes Wahlverwandtschaften," in *Gesammelte Schriften,* ed. Rolf Tiedemann and Hermann Schweppenhäuser (Frankfurt: Suhrkamp Verlag, 1974), Vol. 1, 123–201. A certain sacrifice of the eyes orients H. G. Wells' narrative "The Country of the Blind," in *The Complete Short Stories of H. G. Wells* (London: Ernest Benn, Ltd., 1927), 167–92. Sight is there described as an infirmity, and the right to enter into this society is to be paid for by blindness. Out of love for one of the citizens of this country of the blind—a woman whose father's name is Jacob, like the blind elder of Genesis—Nunez considers "fac[ing] the blind surgeons" and asks himself, "If I were to consent to this [sacrifice]?" (189–90).
78. Gen. 48:10–14.

hand." Diderot's *Letter on the Blind for the Use of Those Who See* describes in two places this vision "by the skin." Not only can one see "by the skin," but the epidermis of the hands would be like a "canvas" stretched taut for drawing or painting:

> Saunderson, then, saw by means of his skin, and this integument of his was so keenly sensitive that with a little practice he could certainly have recognized the features of a friend traced upon his hand, and would have exclaimed, as the result of successive sensations caused by the pencil: "That is so-and-so." Thus the blind have likewise a painting, in which their own skin serves as the canvas. . . . I might add to this account of Saunderson and the blind man of Puisaux, Didymus of Alexandria, Eusebius the Asiatic, and Nicaise of Mechlin, and some other people who, though lacking one sense, seemed so far above the level of the rest of mankind that the poets might without exaggeration have feigned the jealous gods to have deprived them of it, from fear lest mortals should equal them. For what was Tiresias, who had penetrated the secrets of the gods, but a blind philosopher whose memory has been handed down to us by fable?

And in the *Addition to the Preceding Letter:*

> Lastly, I will give you her ideas upon handwriting, drawing, engraving, and painting, and they are, I think, very just. . . . She begins the dialogue: "If you trace on my hand with a point, a nose, a mouth, a man, a woman, or a tree, I should be sure to recognize them; and if the tracing was correct, I should hope to recognize the person whom you had drawn; my hand would become a sensitive mirror, but the difference in sensibility between this hand and the organ of sight is immense. I suppose the eye is a living canvas of infinite delicacy; the air strikes the object, and is reflected back from the object to the eye. . . . If the skin of my hand was as sensitive as your eye, I should see with my hand as you see with your eyes; and I sometimes imagine there are animals who have no eyes, but can nevertheless see. . . . Variety in sensation (and hence in the property of reflecting air), in the materials you employ, distinguishes the writing from the drawing, the drawing from the engraving, the engraving from the picture." [79]

79. Denis Diderot, "Letter on the Blind for the Use of Those Who See," in *Diderot's Early Philosophical Works,* trans. and ed. Margaret Jourdain (Chicago: The Open Court Publishing Company, 1916), 107–8, 155–56. In the same "Letter," Diderot also imagines a duel between two so-called "blind" philosophers—Berkeley and Condillac. In spite of everything that opposes them, they have idealism in common. This term, which was then very new, designates in Diderot's eyes a philosophy for the blind, a philosophy born of a

The author of a *Letter on the Blind* and of the *Salons* was not only a thinker of *mimesis* who was haunted by blindness; he also knew how to write, "in the dark," a blindfolded love letter, a letter drafted for "the first time" "without seeing." He knew how to write:

> I write without seeing. I came. I wanted to kiss your hand and then leave. I will leave without this reward. But perhaps I will be rewarded enough if I have shown you how much I love you. It is nine o'clock. I am writing that I love you, or at least I want to write this; but I do not know if my pen lends itself to my desire. Won't you come, so that I can tell you and then flee? Goodbye, my Sophie, good night. Your heart is obviously not telling you that I am here. This is the first time I have ever written in the dark. Such a situation should inspire me with tender thoughts. I feel only one, which is that I do not know how to leave this place. The hope of seeing you for a moment holds me here, and I go on talking to you, not knowing whether I am indeed forming letters. Wherever there will be nothing, read that I love you. (Letter to Sophie Volland, June 10, 1759)

Subject to being *mistaken,* the blind man is also the *subject of punishment.* As soon as it is assigned a meaning, the blow that makes one lose one's sight inscribes sacrifice into the economic representation of a kind of justice. This fatality is all the more intractable in that it follows a law of retribution or compensation, of exchange and equivalence. The logic of punishment overlaps and recovers the logic of acquittal or repayment. The punishment may annul the evil or even produce a benefit (the interest, the usury of lost eyes). Orion sees himself punished twice for the violence of his desire. He loses his sight, then his life. Yet the solar fire had restored his sight when, after having had his eyes gouged out by Oenopion, Merope's father, he was guided by Cedalion, whom he carried on his shoulders, toward the bedazzling star—this other eye, this eye of the other who saw him coming. And yet [*en revanche*]—it's true—it was the solar venom **60, 61** of a scorpion that eventually put him to death on Artemis' order. For revenge [*une revanche*] also reestablishes equivalence or equity.

Turning into martyrdom, and thus into witnessing, blindness is often the price to pay for anyone who must finally open some eyes, his own or

blind mother or father: "Those philosophers, madam, are termed idealists who, conscious only of their own existence and of a succession of external sensations, do not admit anything else; an extravagant system which should to my thinking have been the offspring of blind parents" (104). And after having associated these two blind-idealists—Condillac and Berkeley, "Would you not be curious to see a trial of strength between two enemies whose weapons are so much alike?" (105).

60. Fontainebleau School, *Orion's Death,* Louvre Museum.

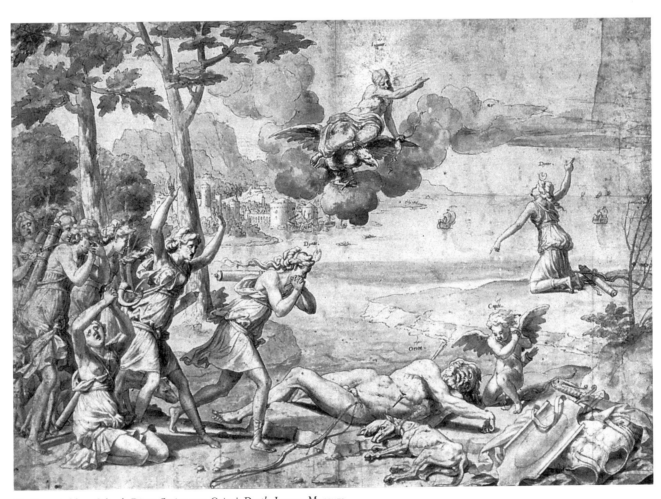

61. Fontainebleau School, *Diana Crying over Orion's Death,* Louvre Museum.

another's, in order to recover a natural sight or gain access to a spiritual light. The paradox stems from the fact that the blind man thus becomes the best witness, a chosen witness. In fact, a witness, as such, is always blind. Witnessing substitutes narrative for perception. The witness cannot see, show, and speak at the same time, and the interest of the attestation, like that of the testament, stems from this dissociation. No authentification can show in the present what the most reliable of witnesses sees, or rather, has seen and now keeps in memory—provided that he has not been borne away by fire. (And as for the witnesses of Auschwitz, like those of all extermination camps, there is here an abominable resource for all "revisionist" denials.)

It is thus always a matter of returning from wandering, of *restituting* a destination, of *restoring* what one should have seen to it not to lose. The punishment of Elymas, to whom sight will in fact be *restored,* itself *restores* **62** to the proconsul the faith from which the magician had tried to turn him away. Saul, who is also Paul, "look[s] intently at him." He is seen pointing his finger in the same direction, on the left of Giulio Clovio's drawing, and the hands of all the characters are outstretched: toward each other, but also toward the center of an invisible presence that orients all the bodies. *Foreseeing* what is about to happen, Paul announces to Elymas that the hand of the Lord is going to cast him into darkness, but only *provisionally* and *providentially.*

> "You son of the devil, you enemy of all righteousness, full of deceit and villainy, will you not stop making crooked the straight paths of the Lord? And now listen—the hand of the Lord is against you, and you will be blind for a while, unable to see the sun." Immediately mist and darkness came over him, and he went about groping for someone to lead him by the hand. When the proconsul saw what had happened, he believed, for he was astonished at the teaching about the Lord.[80]

Is blindness going to be translated by castration? Is anyone still interested in this? To illustrate the overwhelming "truth" of this Freudian axiom (though it is the question of truth that we are here placing under observation—or into memory, and into the memory of the blind), one has all the material for a simple and striking demonstration in the story of Samson. Samson loses every phallic attribute or substitute, his hair and then his eyes, after Delilah's ruse had deceived his vigilance, thereby giving

80. Acts 13 : 10–12.

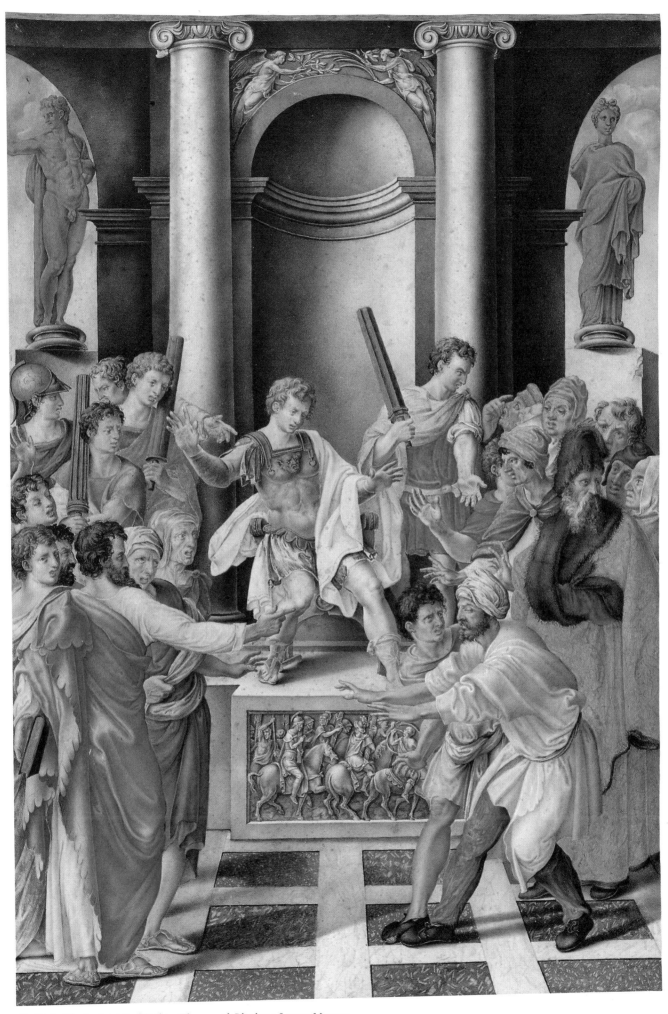

62. Giulio Clovio, *Saint Paul Striking Elymas with Blindness,* Louvre Museum.

him over to a sort of sacrifice, a physical sacrifice. He is not only a figure of castration, a castration-figure, but, a bit like all the blind, like all one-eyed men or cyclopes, a sort of phalloid image, an unveiled sex from head to toe, vaguely obscene and disturbing ("What are they seeking in the heavens, all these blind men?"). He is stretched towards the invisible and threatening place of his desire in an energetic, determined, but uncontrollable movement, being sheer potential, potentially violent, at once groping and sure, between erection and fall, all the more carnal, even animal, in that sight does not protect him, most notably, from shameless gestures. More naked than others, a blind man virtually becomes his own sex, he becomes indistinguishable from it because he does not see it, and not seeing himself exposed to the other's gaze, it is as if he had lost even his sense of modesty. The blind man has no shame, Luther said in short.[81] Following this analogy between the eye and the sex, can it not be said that the eye of the blind man, the blind man himself, derives its strange familiarity, its *disquieting strangeness,* from being more naked? From being exposed naked without knowing it? Indifferent to its nakedness, and thus at once *less naked* and *more naked* than others as a result? More naked because one then sees the eye *itself,* all of a sudden exhibited in its opaque body, an organ of inert flesh, stripped of the signification of the gaze that once came to both animate and veil it. Inversely, the very body of the eye, *insofar as it sees,* disappears in the gaze of the other. When I look at someone who sees, the living signification of their gaze dissimulates for me, in some way and up to a certain point, this body of the eye, which, on the contrary, I can easily stare at in a blind man, and right up to the point of indecency. It follows from this that as a general rule—a most singular rule, appropriate for dissociating the eye from vision—we are all the more blind to the eye of the other the more the other shows themselves capable of sight, the more we can exchange a look or gaze with them. This is the law of the chiasm in the crossing or noncrossing of looks or gazes: fascination by the sight of the other is irreducible to fascination by the eye of the other; indeed, it is incompatible with it. This chiasm does not exclude but, on the contrary, calls for the haunting of one fascination by the other.

81. Cited by Kahren Jones Hellerstedt, "The Blind Man and His Guide in Netherlandish Painting" (*Simiolus,* 13, no. 3/4 [1983]: 18). This fine study concerns numerous works that we have had to leave in the shadows so as to observe the law of this exhibition: to keep to the body of drawings housed at the Louvre.

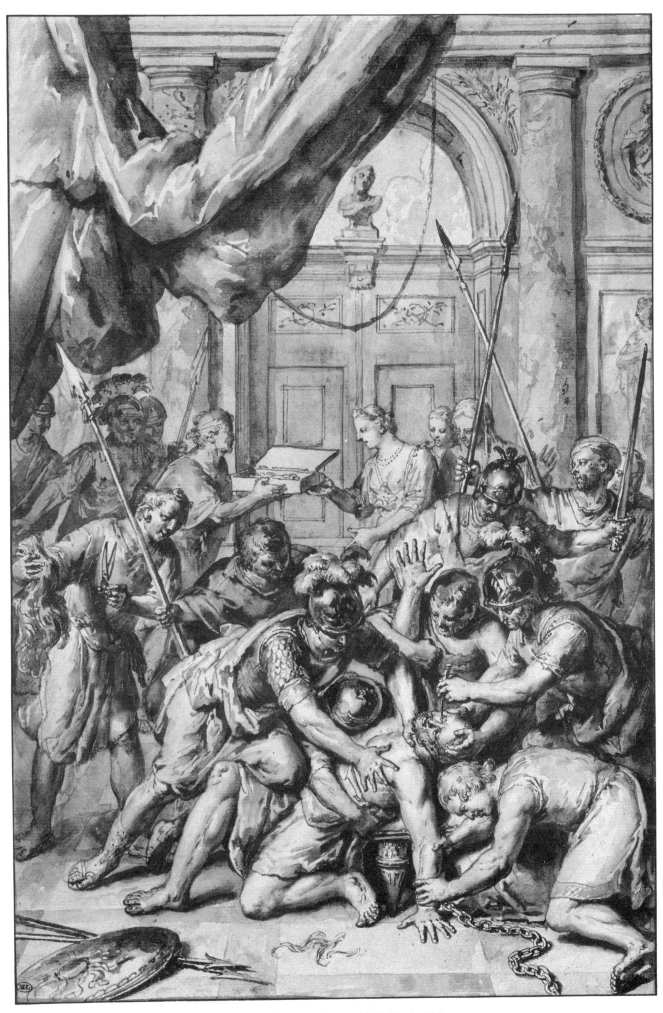

63. Dutch School, end of the seventeenth century, attributed to Hoet, *Samson Blinded by the Philistines*, Louvre Museum.

Is not such phallic obscenity perceptible in this seventeenth-century **63**
Dutch drawing, where one sees all these hands raised up against or coming
down upon Samson? The body is powerful, too powerful. Stretched to the
limit, oblique, exposed, almost naked, it is offered up to all these violent
holds—themselves seized, it seems, by desire. Offered up to the eager,
envious, and impatient gestures of all these soldiers seeking contact with
Samson's skin under the pretext of overcoming the superhuman force of
this stiff and unyielding phallus. It makes one think of a scene of gang
rape. While hands immobilize the smooth skull, a dagger is seen gouging
out the right eye. The flowing locks have already been cut, some are scat-
tered on the floor, but most of them are gathered in a thick mane in the
right hand of a Philistine who holds in his left hand the victorious and
threatening shears.

Samson, the victim of punishment, is also one of the chosen of divine
providence. During Israel's captivity in the land of the Philistines (the
people having already been punished and made to expiate their sins), the
angel of Yahweh announces to Samson's barren mother that she is to have
a son. He will begin to save Israel, but "no razor is to come on his head."
After having taken a wife from among the uncircumcised Philistines, after
all the sudden turns of fortune that lead him into captivity and then into
blindness, after God has "left him," Samson invokes Yahweh, who *restores*
his strength. Samson will save his people by sacrificing himself, along with
the Philistines, after being able once again to get it up [*bander*]—his en-
ergy, that is. Column against column, a column between columns, which all
come tumbling down: the one makes the others fall, on all the others and
on itself. This sacrifice also implies exchange, capital vengeance, vengeance
capitalized upon (not only an eye for an eye but "one act of revenge . . .
for my two eyes"), that is, a usury of memory:

> Then Samson called to the Lord and said, "Lord God, remember me and
> strengthen me only this once, O God, so that with this one act of revenge
> I may pay back the Philistines for my two eyes." And Samson grasped
> the two middle columns on which the house rested, and he leaned his
> weight against them, his right hand on the one and his left hand on the
> other. Then Samson said, "Let me die with the Philistines." He strained
> with all his might; and the house fell on the lords and all the people who
> were in it. So those he killed at his death were more than those he had
> killed during his life.[82]

82. Judg. 16:28–30.

"One act of revenge . . . for my two eyes," the dead were "more than those": in this logic of the *sacrificial supplement,* there is always recompense for ruin, benefits or profits from usury, in short, a *hypothec* of the eyes and a *premium upon blindness.*

It is this calculation, at once blind and providential, this wager on blindness, that Milton translates in that self-portrait called *Samson Agonistes.* Like Samson, the blind poet is chosen by God; a terrible punishment becomes the price to pay for a national mission and a political responsibility. And the blind man *regains,* he guards and regards, retains and recoups, and compensates for what his eyes of flesh have to renounce with a spiritual or inner light—as well as a historical lucidity. For blindness seems to illuminate the "inward eyes":

> But he, though blind of sight,
> Despised and thought extinguished quite,
> With inward eyes illuminated,
> His fiery virtue roused
> From under ashes into sudden flame, . . .[83]

But for Samson, the question remains alive, open, open like a wound but closed upon a secret: if the interiority of light is the life of the soul, then why was it entrusted to the exteriority of the body, imprisoned, "confined" in a ball as vulnerable as the eye?

> Since light so necessary is to life,
> And almost life itself, if it be true
> That light is in the soul,
> She all in every part, why was the sight
> To such a tender ball as th'eye confined?[84]

It is widely conjectured that the attacks upon Milton aggravated the condition of his glaucoma. His enemies did not fail to see in the blindness that struck him around 1652 a punishment, a punishment interpreted by Milton himself as a sacrifice to a "noble cause" (revolution, regicide, the defense of divorce). A sacrifice, certainly, but a sacrifice that is compensated for, or simply motivated by, the gift of visionary prophecy. This is

83. *Samson Agonistes,* lines 1687–91.
84. Ibid., lines 90–94.

what his friend Marvell, the author of "Eyes and Tears," said to him, comparing him to Tiresias:

> Where couldst thou words of such compass find?
> Whence furnish such a vast expense of mind?
> Just Heav'n thee like Tiresias to requite
> Rewards with Prophecy thy loss of sight.[85]

It was, in fact, during a war with the uncircumcised Philistines that the hero of Gaza lost his sight. His trials thus also belong to an archive of politico-military justice and punishment. One might call before an imaginary tribunal, or hang on the wall of the same gallery, all those generals who were condemned to lose their sight or who had to face being blindfolded—all the "Belisariuses" of antiquity, David's, for example, or his rival Peyron's, and all the "Drouots" of modern day court-martials.[86]

64, 65

— If, to believe you, the blind man is indeed the subject of *mistake* or *punishment,* can this really give rise to the *conversion* that you announced? How can blindness *overturn* the subject or *bowl him over, turn him upside down* or *turn him around?* By turning him toward what? A version or turning toward whom?

85. Andrew Marvell, *On Mr. Milton's Paradise Lost* (New York: Penguin), 192. It is known, moreover, that Milton develops an entire theory of the divine or trinitarian Light in *Paradise Lost* as well as in *Christian Doctrine.* The Son is but "bright effluence," the luminosity of the light that comes from the Father. Only this latter is essential light, the essence of light. (I am here drawing upon the unpublished work of a student, Marc Geisler, *A Friendly Struggle: Milton, Marvell and the Liberties of Blindness.*)

86. On the *Belisariuses* of Peyron and David, see the analysis of Régis Michel in *David, l'art et la politique* ([Paris, 1988], 31ff.), who cites Diderot's words before the old general. Condemned by the Emperor Justinian, who was "jealous of his victories," the old general is now fallen, blind, and begging for alms with his helmet, prompting Diderot to say: "I see him all the time and I always believe that I am seeing him for the first time" (Salon of 1781). Attentive to the numerous *mises en scène* of Belisarius, Michael Fried himself (*Absorption,* 146–60) cites a letter by Diderot (July 18, 1762) that enters right into this problematic of "absorption," of the supposition of the beholder, of the inscription of the *point of view* as a *taking part [partie prenante]* in the picture [it will be recalled that the Louvre series inaugurated by *Memoirs of the Blind* is entitled *"Parti Pris"*—Trans.]. Must the draftsman annul the hypothesis of the beholder? Must he make as if there were no beholder or suppose the visitor to be blind? Yes, according to Diderot: "If, when one makes a painting, one supposes beholders, everything is lost. The painter leaves his canvas, just as the actor who speaks to the audience steps down from the stage. . . . Does not the figure of Belisarius achieve the effect that he must achieve! What does it matter if one loses sight of him?" (*Absorption,* 148).

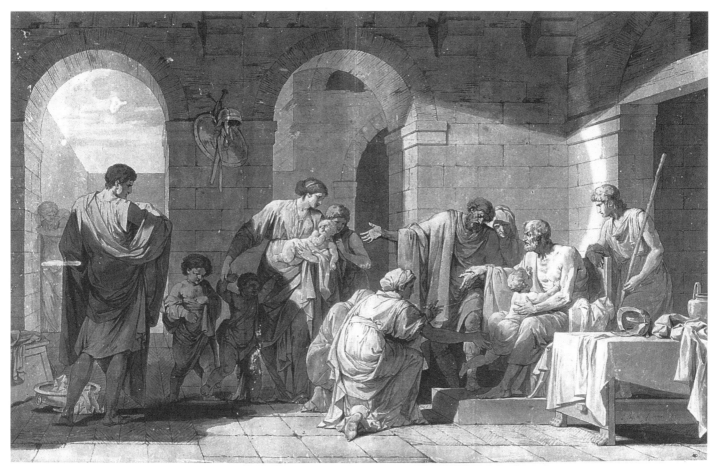

64. Pierre Peyron, *Belisarius,* Louvre Museum.

65. Jean-Baptiste Isabey, *General Drouot,* Louvre Museum.

— Each time a divine punishment is cast down upon sight in order to signify the mystery of election, the blind become witnesses to the faith. An inner conversion at first seems to transfigure light itself. Conversion of the inside, conversion on the inside: in order to enlighten the spiritual sky on the inside, the divine light creates darkness in the earthly sky on the outside. This veil between two lights is the experience of bedazzlement, the very bedazzlement that, for example, knocks Paul to the ground on the road to Damascus. A conversion of the light literally bowls him over. Oftentimes his horse is also thrown violently to the ground, bowled over or knocked to the ground in the same fall, its eyes sometimes turned like its master's toward the blinding source of the light or the divine word. In Caravaggio's painting (Rome, Santa Maria del Popolo), only the horse remains standing. Lying outstretched on the ground, eyes closed, arms open and reaching up toward the sky, Paul is turned toward the light that bowled him over. The brightness seems to fall upon him as if it were reflected by the animal itself. In addition to being mentioned in the Letter to the Galatians,[87] the conversion is described three times in the Acts of the Apostles. The first account does not come from Paul's (or Saul's) mouth and is a more visual narration of the event:

66, 67

68

> Now as he was going along and approaching Damascus, suddenly a light from heaven flashed around him. He fell to the ground and heard a voice saying to him, "Saul, Saul, why do you persecute me?" He asked, "Who are you, Lord?" The reply came, "I am Jesus, whom you are persecuting. But get up and enter the city, and you will be told what you are to do." The men who were travelling with him stood speechless because they heard the voice but saw no one. Saul got up from the ground, and though his eyes were open, he could see nothing; so they led him by the hand and brought him into Damascus. For three days he was without sight, and neither ate nor drank.[88]

It is during a vision that God appears to the disciple Ananias to confer upon him the mission of laying hands on Saul during prayer (and also

87. Gal. 1:12–24. This letter establishes a particularly close connection between the theme of *conversion* (always an experience of the interior gaze turned toward the light at the moment of revelation, which is to say, at the moment of truth) and the theme of *circumcision*. This latter becomes useless after the revelation or the "unveiling" of Christ: "For in Christ Jesus neither circumcision nor uncircumcision counts for anything; the only thing that counts is faith working through love" (Gal. 5:6).

88. Acts 9:3–9.

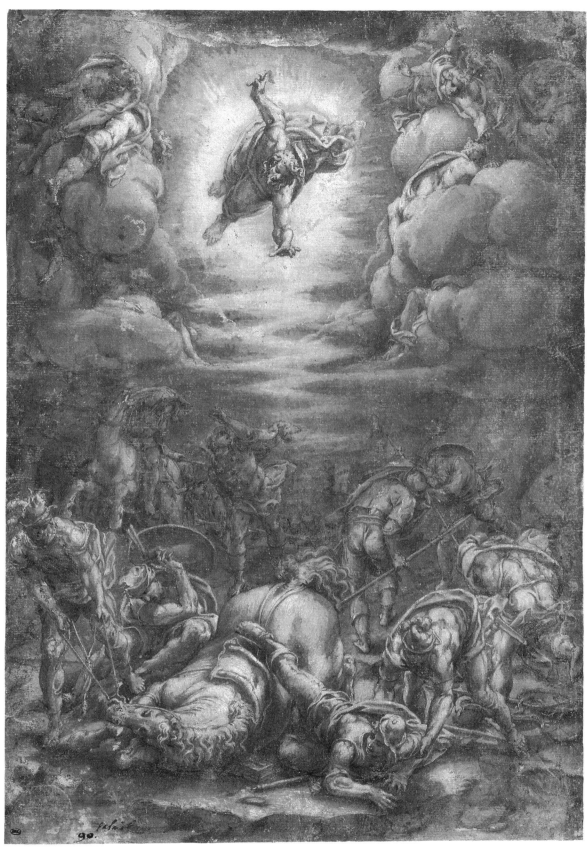

66. Lelio Orsi, *The Conversion of Saint Paul,* Louvre Museum.

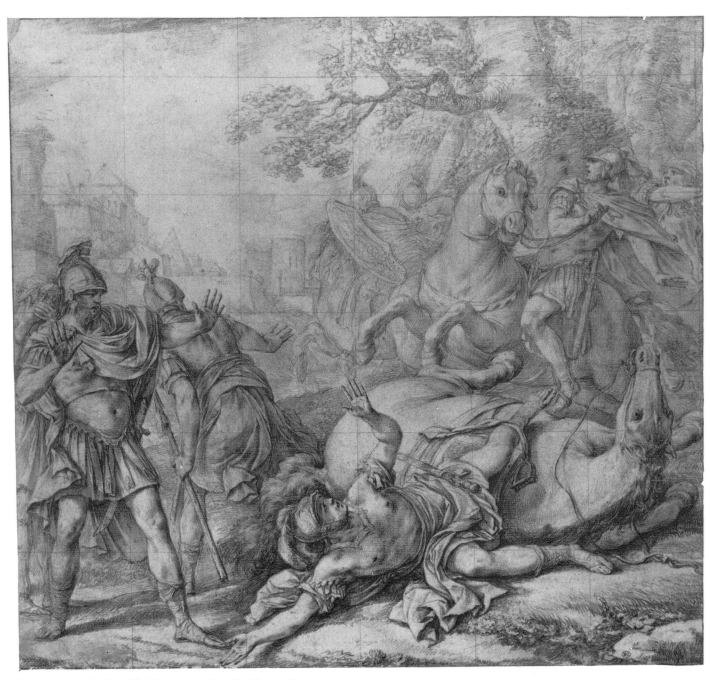

67. Laurent de La Hyre, *The Conversion of Saint Paul,* Louvre Museum.

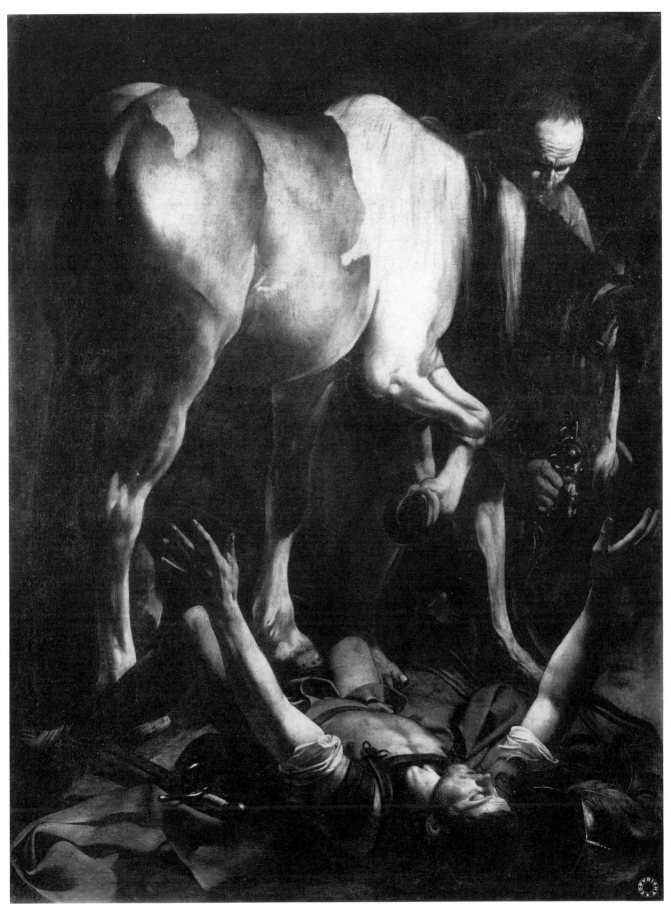

68. Caravaggio, *The Conversion of Saint Paul,* Rome, Santa Maria del Popolo.

during one of Saul's visions: the narrative of a vision within a vision). And this, "so that he might regain his sight":

> The Lord said to [Ananias], "Get up and go to the street called Straight, and at the house of Judas look for a man of Tarsus named Saul. At this moment he is praying, and he has seen in a vision a man named Ananias come in and lay his hands on him so that he might regain his sight." . . . So Ananias went and entered the house. He laid his hands on Saul and said, "Brother Saul, the Lord Jesus, who appeared to you on your way here, has sent me so that you may regain your sight and be filled with the Holy Spirit." And immediately something like scales fell from his eyes, and his sight was restored. Then he got up and was baptized, and after taking some food, he regained his strength.[89]

The other two versions of the narrative are memoirs, the confessions or the self-portrait of a convert. Saul speaks in the first person. He puts more emphasis on the figure of the blind man as a witness. The blind man's privilege is that he will have heard as well as seen.

> I fell to the ground and heard a voice saying to me, "Saul, Saul, why are you persecuting me?" . . . Now those who were with me saw the light but did not hear the voice of the one who was speaking to me. [And then Ananias speaks]: The God of our ancestors has chosen you to know his will, to see the Righteous One and to hear his own voice; for you will be his witness to all the world of what you have seen and heard. . . . After I had returned to Jerusalem and while I was praying in the temple, I fell into a trance and saw Jesus saying to me, "Hurry and get out of Jerusalem quickly, because they will not accept your testimony about me."[90]

In the second autobiographical narrative, the destination of this testimony of conversion is seen to be even more clearly assigned. It is a question, this time, of converting others and turning their eyes—open at last—toward the light, a question of turning them away from darkness and from Satan (the angel of light but also of blindness) in order to recall them to God, in order for God to call them back to Him.

> ". . . for I have appeared to you for this purpose, to appoint you to serve and testify to the things in which you have seen me and to those in which

89. Acts 11:19.
90. Acts 22:7–18.

I will appear to you. I will rescue you from your people and from the Gentiles—to whom I am sending you to open their eyes so that they may turn from darkness to light and from the power of Satan to God. . . ." After that, King Agrippa, I was not disobedient to the heavenly vision, but declared . . . that they should repent and turn to God and do deeds consistent with repentance.[91]

Sunflower blindness, a conversion that twists the light and turns it upon itself to the point of dizziness, the blacking out of the one bedazzled, who sees himself go from brightness and clarity to even more clarity, perhaps to too much sun. This clarivoyance of the all-too-evident is Paul's madness. And one blames it on books, in other words, on the visibility of the invisible word: Festus cries, "You are out of your mind, Paul! Too much learning [grammata] is driving you mad!" One can bet that Paul's confession, the self-portrait of this mad light, will have come to represent the model of the self-portrait, the one that concerns us here in its very ruin . . .

— You mean yours?

— Anyone's—anyone among us, in our culture, who says "mine." This is what I also call the hypothesis of sight, that is, the suspension of the gaze, its "epoch" (epochē means interruption, cessation, suspension, and sometimes the suspension of judgment, as in the skepsis that we spoke of in the beginning). In Christian culture there is no self-portrait without confession. The author of the self-portrait does not *show* himself; he does not *teach* anything to God, who knows everything in advance (as Augustine never ceases to recall). The self-portraitist thus *does not lead one to knowledge,* he admits a fault and asks for forgiveness. He "makes" truth, to use Augustine's word, he *makes [fait] the light* of this narrative, *throws light* on it, in order to make the love of God grow within him, "for love of your love."[92] At the heart of the *Confessions,* at the moment when the self-portraitist fends off the temptations of sight and calls for this conversion from the light to the light, from the outward realm to the realm within, it is a theory of the blind that unfolds, a procession [théorie] of the blind that files past. All the Tobits of the Scriptures are called together in his

91. Acts 26:16–20.

92. Augustine, *Confessions* 11.1. [We have used the translations of both R. S. Pine-Coffin (New York: Penguin, 1961) and William Watts (Loeb, 1989). —Trans.]

memory, along with Isaac and Jacob. But not Paul, because of or in spite of the fact that he is here the closest model, the blind spot at this point of the *Confessions,* which themselves turn round a conversion. And the evil comes as much from forms as from colors:

> Finally I must confess how I am tempted through the eye. . . . The eyes delight in beautiful shapes of different sorts and bright and attractive colors. I would not have these things take possession of my soul. Let God possess it. . . . For light, the queen of colors, pervades all that I see, wherever I am throughout the day, and by the everchanging pattern of its rays it entices me *(blanditur mihi)* even when I am occupied with something else and take no special note of it. It wins so firm a hold on me that, if I am suddenly deprived of it, I long to have it back, and if I am left for long without it, I grow dispirited.
>
> But the true Light is the Light that Tobit saw when, though his eyes were blind, he taught his son the path he should follow in life, and himself led the way, charity guiding his steps so that he did not stray. It is the Light that Isaac saw when, though the sight of his eyes was dimmed and clouded by old age, it was granted to him not to bless his sons in full knowledge as to which was which but to know them by blessing them. It is the Light that Jacob saw when, though his eyes were blinded by old age, a Light shone in his heart and cast its beams over the tribes of Israel yet to come, foreseen *(praesignata)* in the persons of his sons. It is the Light that he saw when he laid his hands on his grandchildren, the sons of Joseph, not in the way that their father, who saw with only an outward *(foris)* eye, tried to make him do it, but mystically crossed, in the way that he discerned by the Light that shone within *(intus)* him. This is the true Light. It is one alone and all who see and love it are one *(ipsa est lux, una est et unum omnes, qui vident et amant eam).*
>
> As for the corporeal light of which I was speaking, it seasons the life of this age for those who blindly love it *(condit vitam saeculi caecis amatoribus)* with a tempting and dangerous sweetness. Yet those who have learned to praise you for this as well as for your other gifts, *O God, Maker of all things,* take it up *(adsumunt eam)* by singing you a hymn of praise, for they are not taken in by it *(non absumuntur ab ea)* in their sleep.[93]

At the same time as he denounces the secular light of the age, of the *siècle*—and the *siècle* is itself defined by the corporeal light*—Saint Au-

*Derrida is drawing attention to Augustine's use of the Latin *saeculum,* from which come both our word "secular" and the French word *siècle*—meaning century or age. —Trans.

93. *Confessions* 10.34.

gustine denounces the sleep that closes our eyes to the true light within. But he also indicts works of art, and most notably, paintings, "all these . . . additional temptations to the eye that men follow outwardly, inwardly forsaking the one by whom they were made, ruining what he made of them." The *Confessions* are presented as a sort of testimony for Christian brothers, but this attestation is a discourse—in the form of a self-portrait—about this ruin and this sacrifice. The confession "raises up invisible eyes" against the "*concupiscentia oculorum*":

> I resist the allurements of the eye for fear that as I walk upon your path, my feet may be caught in a trap. Instead, I raise my invisible eyes to you (*et erigo ad te invisibiles oculos*), so that you may *save my feet from the snare*. Time and again you save them, for I fail to escape the trap. You never cease to free me, although again and again I find myself caught in the snares that are laid about me. For you are *the guardian of Israel, who is never weary, never sleeps.*
>
> By every kind of art and the skills of their hands men make innumerable things—clothes, shoes, pottery, and other useful objects, besides pictures and various images (*picturis etiam diversisque figmentis*). They make them on a far more lavish scale than is required to satisfy their own modest needs or to express their devotion. And all these things are additional temptations to the eye that men follow outwardly (*foras*), inwardly (*intus*) forsaking the one by whom they were made, ruining (*exterminantes*) what he made of them. But, O my God, my Glory, for these things too I offer you a hymn of thanksgiving. I make a sacrifice of praise to him who sanctifies me. . . .[94]

Would Saint Augustine thus condemn the temptations of *all* Christian painting? Not at all, just so long as a conversion saves it. A sort of allegory makes corporeal vision conform to divine vision. In this case, allegory would not exclude analogy. Quite the contrary. Such an allegorical conversion would recall a relation of resemblance between the human eye and this divine eye that is at once the one and only source of light, visibility itself, and the place of a monocular vision. The hymn would sing the praises of the divine eye simply by looking at it, by looking at itself looked after and looked at, guarded and regarded, by God. Just as "those who blindly love" this "corporeal light" can save themselves by taking in and taking up (*adsumunt*) this light to praise the light of the Lord, so the

94. Ibid.

69. Jan Provost, *Sacred Allegory*, Louvre Museum.

painter saves his painting by showing this exchange of glances. Such an exchange is at once specular and hierarchized, that is, oriented, respectful of the infinite distance that the painter contemplates, and dissymmetrical (a mirror from on high below, or from below on high): between human and divine vision. The painting *becomes* this allegory, it shows the exchange of glances that makes painting possible. Whatever its symbolic over-determination, Jan Provost's *Sacred Allegory*[95]—of which this is not an analysis—must always be able to be contemplated as the representation or reflection of its own possibility. It puts on the scene, it stages, the opening scene of sacred painting, an allegorical self-presentation of this "order of the gaze" to which any Christian drawing must submit. This putting to work of the self-presentation does not suspend—no more than it ever does—reference to the outside, as is so often and so naively believed. The desire for self-presentation is never met, it never meets up with itself, and that is why the simulacrum takes place. Never does the eye of the Other recall this desire more sovereignly to the outside and to difference, to the law of disproportion, dissymmetry, and expropriation. And this is memory itself. To "contemplate" this picture in this way, the gaze must become Christian; it is not that it must already be converted, but it must be in the process of conversion, learning to see the divine condition of the picture itself. Learning to see on this condition, which is possible only in hymn or prayer.

69

A Christian drawing should be a hymn, a work of praise, a prayer, an imploring eye, an eye with joined hands, an *imploring* that is lifted up, an imploring of surrection and resurrection (everything here becomes ascension and verticality of the gaze, except for the eye of God, without which everything would be blinded), like the eyes of the son and his mother who look in the same direction. Imploration, revelation, sacrifice (even the sacrificial Lamb holds between his hoofs, like so many of the blind, the raised banner of salvation): this allegory shows the eye of the Other only by unveiling the allegory of showing itself, the allegory of drawing as apocalypse. For this shows an apocalypse, as the allusion to the Apocalypse of John—to the book "sealed with seven seals"[96]—suggests. As its name indicates, the *apocalypsis* is nothing other than a revelation or a laying bare, an un-

95. See "Une allégorie sacrée de Jan Provost," by Nicole Reynaud, in *Revue du Louvre* (Paris, 1975), no. 1, 7. This allegory is sometimes called "Christian" rather than "sacred."
96. Rev. 5 : 1.

veiling that renders visible, the truth of truth: light that shows itself, as and by itself. This is an apocalypse of painting—as Christian painting. Everything here is at once overturned and put back in place, from on high to down below, from top to bottom and all the way through. Yet the second meaning of apocalypse does not come as a secondary grafting onto the first, for if revelation or contemplation *(Hazôn)* brings to light what was already *there* from the beginning, if the apocalypse shows this *there,* then it also unveils in accordance with the event of a catastrophe or cataclysm. Order and ruin are no longer dissociated at the origin of drawing—and neither are the transcendental structure and the sacrifice—even less so when drawing shows its origin, the condition of its possibility, and the coming of its event: a work. A work is at once order and its ruin. And these weep for one another. Deploring and imploring veil a gaze at the very moment that they unveil it. By praying on the verge of tears, the sacred allegory *does [fait]* something. It makes something happen or come, makes something come to the eyes, makes something well up in them, by producing an event. It is performative, something vision alone would be incapable of if it gave rise only to representational reporting, to perspicacity, to theory or to theater, if it were not already potentially apocalypse, already potent with apocalypse. By blinding oneself to vision, by veiling one's own sight—through imploring, for example—one *does* something with one's eyes, *makes* something of them. One does something to one's own eyes.

Memoirs and self-portrait, Saint Augustine's *Confessions* no doubt tell a prehistory or pre-story of the eye, of vision or of blindness. But before saying why I have always read them as the great book of tears, I would like to recall here the Dionysian counter-confessions of another blind man, Nietzsche's *Ecce Homo.* It is once again a question of a duel in *contre-jour,* a duel between Dionysus and his other, Perseus, his half-brother, or Apollo, the god of light and of the gaze, of form or of figure, the Apollonian ecstasy "maintaining the eye above all else at the level of excitation so that it might receive the power of vision" *(Twilight of the Idols).* Between Apollo and Dionysus a "fraternal bond" is certainly possible,[97] if we are to believe Nietzsche, but only after a war of eyes and an apotropaic scene between enemy brothers. Nietzsche sees the Medusa between them, like a figure of death. *The Birth of Tragedy* had described the Dionysian festivals,

97. Friedrich Nietzsche, *The Birth of Tragedy,* trans. Walter Kaufmann (New York: Vintage Books, 1967), 139.

with their "extravagant sexual licentiousness" and "savage natural instincts," their "horrible mixture of sensuality and cruelty":

> For some time, however, the Greeks were apparently perfectly insulated and guarded against the feverish excitements of these festivals, though knowledge of them must have come to Greece on all the routes of land and sea; for the figure of Apollo, rising full of pride, held out the head of the Medusa to this grotesquely uncouth Dionysian power—and really could not have countered any more dangerous force. It is in Doric art that this majestically rejecting attitude of Apollo is immortalized. [And it was then that] the two antagonists were reconciled.[98]

Nietzsche never had words cruel enough for Saint Paul and Saint Augustine. Yet however much his *Ecce Homo* plays off the Anti-Christ and Dionysus "against the Crucified" *(Dionysos gegen den Gekreuzigten),* the book is still the self-portrait of a blind man, and of a blind son gifted with a second, even a third, sight. He presents himself as an expert on shadows, to whom was given the experience of blindness. Such blindness threatened him, in fact, when he reached the age at which his father died:

> In the same year in which his life went downward, mine, too, went downward: at thirty-six, I reached the lowest point of my vitality—I still lived, but without being able to see three steps ahead of me. . . . [I] spent the summer in St. Moritz like a shadow *(wie ein Schatten),* and the next winter—not one in my life has been in poorer sunshine—in Naumburg *as* a shadow *(als Schatten).* This was my minimum: the *Wanderer and His Shadow* originated at this time. Doubtless, at that time I knew about shadows. . . . My eye trouble too, though at times dangerously close to blindness *(dem Blindwerden zeitweilig sich gefährlich annähernd),* is only a consequence and not a cause: with every increase in vitality *(Leben-*

98. Ibid., 39. "This reconciliation is the most important moment in the history of the Greek cult: wherever we turn we note the revolutions resulting from this event." And later: "And behold: Apollo could not live without Dionysus! The 'titanic' and the 'barbaric' were in the last analysis as necessary as the Apollonian" (46). As for the place of the third, the witness and the observer, Nietzsche assigns him the point of view of the chorus in Greek tragedy. Commenting upon one of Schlegel's formulae, Nietzsche writes: ". . . the chorus is the 'ideal spectator *(Zuschauer)*' insofar as it is the only *beholder (Schauer),* the beholder of the visionary world of the scene. A public of spectators as we know it was unknown to the Greeks" (62–63). On the themes of blindness, the wounded gaze ["when after a forceful attempt to gaze on the sun we turn away blinded . . ."], the Apollonian or Dionysian mask, spectrality ["the bright image projections of the Sophoclean hero"], etc., see 66ff. As for the blind Homer, Nietzsche says that he writes in a much more "vivid" *(anschaulich)* way because he knows how to "visualize so much more vividly *(anschauen)*" (63–64).

70. Charles Le Brun, *Weeping,* Louvre Museum.

71. Daniele da Volterra, *Woman at the Foot of the Cross,* Louvre Museum.

skraft) my ability to see *(Sehkraft)* has also increased again. . . . I am a *Doppelgänger,* I have a "second" sight *[Gesicht]* in addition to the first. *And* perhaps also a third.[99]

And Nietzsche wept a lot. We all know about the episode in Turin, for example, where his compassion for a horse led him to take its head into his hands, sobbing. As for the *Confessions,* we said that it is the book of tears. At each step, on each page, and not only at the death of his friend or his mother, Augustine describes his experience of tears, those that inundate him, those in which he takes a surprising joy, asking God why tears are sweet to those in misery *(cur fletus dulcis sit miseris),*[100] those that he holds back, in himself or in his son. Now if tears *come to the eyes,* if they *well up in them,* and if they can also veil sight, perhaps they reveal, in the very course of this experience, in this coursing of water, an essence of the eye, of man's eye, in any case, the eye understood in the anthropo-theological space of the sacred allegory. Deep down, deep down inside, the eye would be destined not to see but to weep. For at the very moment they veil sight, tears would unveil what is proper to the eye. And what they cause to surge up out of forgetfulness, there where the gaze or look looks after it, keeps it in reserve, would be nothing less than *alētheia,* the *truth* of the eyes, whose ultimate destination they would thereby reveal: to have imploration rather than vision in sight, to address prayer, love, joy, or sadness rather than a look or gaze. Even before it illuminates, revelation is the moment of the "tears of joy."

What does the anthropo-theological discourse (which we shall leave open here like an eye, the most lucid and the most blind) say about this? That if the eyes of all animals are destined for sight, and perhaps by means of this for the scopic knowledge of the *animal rationale,* only man knows how to go beyond seeing and knowing *[savoir],* because only he knows how to weep. ("But only human eyes can weep," writes Andrew Marvell.) Only man knows how to see this *[voir ça]*—that tears and not sight are the essence of the eye. The essence of the eye is proper to man. Contrary to what one believes one knows, the best point of view (and the *point of view* will have been our theme) is a source-point and a watering hole, a water-point—which thus comes down to tears. The blindness that opens the eye

99. Friedrich Nietzsche, *Ecce Homo,* trans. Walter Kaufmann (New York: Vintage Books, 1969), 222, 223, 225.
100. *Confessions* 4.5.

is not the one that darkens vision. The revelatory or apocalyptic blindness, the blindness that reveals the very truth of the eyes, would be the gaze veiled by tears. It neither sees nor does not see: it is indifferent to its blurred vision. It implores: first of all in order to know from where these tears stream down and from whose eyes they come to well up. From where and from whom this mourning or these tears of joy? This essence of eye, this eye water?

In drawing those who weep, and especially women (for if there are many great blind men, why so many weeping women?), one is perhaps seeking to unveil the eyes. To say them without showing them seeing. To recall. To pronounce that which, in the eyes, and thus in the drawing of men, in no way regards sight, has nothing to do with it. Nothing to do with the light of clairvoyance. One can see with a single eye, at a single glance, whether one has one eye or two. One can lose or gouge out an eye without ceasing to see, and one can still wink with a single eye.

— Isn't that in fact what happened to you, as you explained earlier?

— Exactly, and that did not prevent me from seeing. In other words, two eyes can always become dissociated from the point of view of the view, of sight. From the point of view of their organic *function.* But it is the "whole eye," the whole of the eye, that weeps. It is impossible to weep with a single eye when one has two, or even, I imagine, when one has a thousand, like Argus (whose eye is multiplied on the surface of his body, according to Hegel's *Aesthetics,* like the manifestation of the soul, like the light of the inside on the outside: "All in every part," said Milton's Samson, that is, completely whole, like the soul, in every part, in every place, at every point along its surface).

This is the moment to specify the *abocular* hypothesis—or the epoch of sight. Blindness does not prohibit tears, it does not deprive one of them. If the blind man weeps in asking for pardon (Samson: "His pardon I implore"), if a drawing of the blind recalls this, one catches a glimpse of this question: for whom does the drawing weep? For what? For sight or for the eyes? And what if these were not the same thing? For whose sight or whose eyes? Let's not forget that one can also hide one's tears (which amounts to dissimulating what comes to veil sight: look at Lairesse's *Venus Crying* or Daniele da Volterra's weeping woman). One can first of all weep without **71** tears. In the descriptions it gives of "Weeping," Le Brun's *A Method to Learn to Design the Passions* hardly mentions tears. They do not appear in

Le Brun's graphic representations.[101] Is this because he is describing man's **70**
Weeping? Would he oppose this to a woman's tear? What then is to be
made here of sexual difference? And of the Tiresias within us?

Marvell compared his friend Milton to Tiresias. The poet of *Samson
Agonistes* would have received blindness as a blessing, a prize, a reward, a
divine "requital," the gift of poetic and political clairvoyance, the chance
for prophecy. There is nothing marvelous or astonishing in this: Marvell
believed he knew that in losing his sight man does not lose his eyes. On
the contrary. Only then does man begin to *think* the eyes. His own eyes
and not those of just any other animal. Between seeing and weeping, he
sees between and catches a glimpse of the difference, he keeps it, looks
after it in memory—and this is the veil of tears—until finally, and from or
with the "same eyes," the tears see:

> How wisely Nature did decree,
> With the same eyes to weep and see!
> That having viewed the object vain,
> We might be ready to complain
>
> .
>
> Open then, mine eyes, your double sluice,
> And practise so your noblest use;
> For others too can see, or sleep,
> But only human eyes can weep.
>
> .
>
> Thus let your streams o'erflow your springs,

101. "Weeping. In Weeping the Eye-brow falls toward the middle of the Forehead; the
Eyes are almost shut, very wet and cast down towards the Cheeks; the Nostrils swelled; all
the muscles and veins of the Forehead very visible; the Mouth half open, down at the
corners, and making wrinkles in the Cheeks; the Under-lip will appear hanging down and
pouting out; the whole Face wrinkled and knit; the color very red, especially about the
Eye-brows, the Eyes, the Nose, and the Cheeks." (*A Method to Learn to Design the Pas-
sions. Conference by Mr. Le Brun, Chief Painter to the French King, to the Academists in the
Royal Academy in Paris,* 1734, trans. John Williams [Los Angeles: University of California,
The Augustan Reprint Society, William Andrews Clark Memorial Library, University of
California, Los Angeles, 1980], 44). One will have noticed the insistence on falling (the
word "*abbessé*"—[translated as falls, cast down, down—Trans.]—appears three times)
and on the eyebrow rather than the eyes. This is one of Le Brun's axioms. The eyebrow
plays the most significant part in this treatise or portrait of the passions: "And as the gland,
in the middle of the brain, is the place where the Soul receives the images of the Passions;
so the Eye-brow is the only Part of the whole face where the Passions best make themselves
known; tho' many will have to be in the Eyes. 'Tis certain, the Pupil, by its fire and motion,
perfectly well shows the Agitation of the Soul, but then it does not express the Kind or
Nature of such an agitation" (*Method to Learn,* 20–21).

Till eyes and tears be the same things:
And each the other's difference bears;
These weeping eyes, those seeing tears.[102]

— Tears that see . . . Do you believe?

— I don't know, one has to believe. . .

102. Andrew Marvell, "Eyes and Tears," in *The Complete Poems* (New York: Penguin Books, 1986).

Illustrations

Notes were compiled by Yseult Séverac for the exhibition catalog. The exhibition number
appears in brackets at the end of relevant entries. Dimensions (height × width) are given
in centimeters.

10 Jacques-Louis David (1748–1825), *Homer Singing His Poems,* Louvre Museum 19

> Graphite reworked with red chalk, pen and black ink, gray wash (27.2 × 34.5). Said to have been drawn by the artist in the autumn of 1794 as a study for a painting that was to be dedicated to Homer. The painting, which was never realized, was planned from a jail in Luxembourg where the artist had been incarcerated following the events of Thermidor. [5]

11 Francesco Primaticcio (1504–70), *Isaac Blessing Jacob,* Louvre Museum 22

> Red chalk, heightened with white (25.9 × 31). Inscribed at upper left in brown ink: *Bologne,* and at lower right: *93.* One of the few drawings by Primaticcio illustrating a religious theme. The drawing is not linked to any known decoration, but can be paired with *Eliezer and Rebecca,* a drawing of the same technique. [38]

12 Jacopo Ligozzi (1547–1626), *Tobias and the Angel,* Louvre Museum 25

> Pen and brown ink, brown wash, heightened with gold, squared (30.7 × 23). Monogrammed at lower left and dated: *1605.* Inscribed on the verso of the mounting in pen and brown ink: *Jacopo Ligozzi Veronese.* Tobias [in French, Tobie], following the angel Raphael's advice, gathers fish gall with which to exorcize his wife Asmodea and heal his father Tobit [in French, Tobie]. Nothing allows us to link this drawing by Ligozzi, a painter who exercised his many talents in the service of the grand duke of Tuscany, to any painted composition. The naturalism in the depiction of the fish recalls the artist's beginnings as a painter of plants and animals. [7]

13 Pietro Bianchi, *Tobias Healing his Father's Blindness,* Louvre Museum 25

14 After Peter Paul Rubens, *Tobias Healing his Father's Blindness,* Louvre Museum 25

15 Rembrandt (attributed to), *Tobias Healing his Father's Blindness,* Louvre Museum 27

> Pen and brown ink, brown and gray washes (18.7 × 25.5). Inscribed at lower right in pen and black ink: *Rimbren,* and at the lower left of the mounting: *Rimbrant.* Following the angel Raphael's advice, Tobias would have restored his father's sight by applying fish gall to his eyes (Tobit 11:11–15). Recent criticism tends to exclude this piece from the authentic corpus of the numerous drawings that Rembrandt devoted to Tobias' story, beginning in 1637, the year when the veterotestamentary book, which until then had been apocryphal, was added to the Lutheran Bible. [8]

> Pen and brown ink, brown wash (26.6 × 22.3). Inscribed at upper left in pen and brown ink on two lines: DELLA SCOLTURA SI / DELLA PITTURA NO. The drawing, attributed to the studio of Guercino, illustrates the theme of the *paragone* or comparison between painting and sculpture, by means of which the primacy of one of the two arts was to be determined. This debate, started in 1546 by the Florentine erudite Benedetto Varchi, interested Italian artists throughout the second part of the sixteenth century. One such artist was the sculptor Tribolo, who, in 1546, called on the arbitration of a blind man in order to demonstrate the superiority of his art by virtue of its tactile character. In 1564, refuting Tribolo's conclusions, Vincenzio Borghini, a professor at the Firenze Academy, claimed that sight was not inferior to touch. As proof, he offered the regrets expressed by the blind man called as arbiter that he could not admire a painting of the great deeds of Alexander the Great, whose statue he had just touched.
>
> More faithful, it seems, to Tribolo's conclusions, the Louvre drawing demonstrates that the matter still aroused deep interest in the seventeenth century. The story is also told in Richardson's *Treatise* on painting and sculpture published in Amsterdam in 1728. [9]

> Oil on canvas (267 × 132). Illustration of the then fashionable theme of Butades, borrowed from Pliny, that shows the young Corinthian tracing the traits of her lover, who must leave her, on a wall. This painting by Suvée, David's hated rival at the Grand Prix of 1771, elicited a fair share of criticism when it was presented at the Salon of 1791 before being offered to the Bruges Academy. A second, smaller version (108 × 76 cm), presented at the Salons of 1791 and 1793 but later lost, is perhaps the one ordered by the Society of the Friends of the Arts. The inventory of possessions seized from Simon-Charles Boutin, a Treasurer of the Navy guillotined in 1793, attests to the existence of a third version that has not been located. [1]

> Charcoal (19.3 × 11.7). Inscribed at bottom: *19 janvier 1871.* Signed at lower left: *Fantin.* [11]

22 Henri Fantin-Latour, *Self-Portrait,* Louvre Museum, Orsay Museum Collection 58
> Charcoal (19.3 × 11.7). Inscribed at bottom: *20 janvier 1871.* Signed at lower left: *Fantin.* [12]

23 Henri Fantin-Latour, *Self-Portrait,* Denver, The Denver Art Museum (gift of Edward and Tullah Harley) 58

24 Henri Fantin-Latour, *Self-Portrait,* Louvre Museum, Orsay Museum Collection 58
> Charcoal estompe (18.1 × 14.4). Inscribed on the mounting in graphite: *h. Fantin / 18 octobre 1860.* This drawing, executed in 1860, is one of a number of scrupulously dated studies that grew from the artist's increasing interest in his own physiognomy. It was done at a time when the young Fantin-Latour began a series of portraits of those in his circle, thus moving away from copying the masters. This prolific production stops after 1872. [10]

25 Henri Fantin-Latour, *Self-Portrait,* Louvre Museum, Orsay Museum Collection. 59
> Charcoal estompe, reworked with brush (14.2 × 12). Drawn in 1860. [13]

26 Henri Fantin-Latour, *Self-Portrait,* Louvre Museum, Orsay Museum Collection 59
> Pen and oily black ink, black wash (23.2 × 23.2). Marked (Lugt 919e) at lower left: *Fantin.* Drawn around 1860. [14]

27 Henri Fantin-Latour, *Self-Portrait,* Louvre Museum, Orsay Museum Collection 59
> Pen, brush, and black ink accentuated by gum arabic, scraped. The face reworked with graphite (21.5 × 21). Marked (Lugt 919e) at lower right: *Fantin.* [15]

28 Théo Van Rysselberghe (1862–1926), *The Sculptor Alexandre Charpentier in front of his Easel,* Louvre Museum, Orsay Museum Collection 61
> Brown chalk on blue paper glued onto cardboard (94 × 70). Monogrammed at upper right. Inscribed at upper right in white pencil: *à mon camarade Alex. Charpentier,* and dated on both sides with the monogram *19 01.* Closely involved with the Parisian avant-garde during the last decade of the nineteenth century, Belgian artist Théo Van Rysselberghe probably met Alexandre Charpentier (1856–1909) through his friend, the Belgian sculptor Constantin Meunier. [19]

29 In the manner of Pieter Bruegel, *Pieter Bruegel in his Studio,* Louvre Museum 61

30 François Stella (1563–1605), *Ruins of the Coliseum in Rome,* Louvre Museum 66
> Pen and brown ink, brown wash (28.2 × 42.9). Inscribed at bottom left

in pen and brown ink on two lines: *Una delle grote/del coliseo di drentro a Roma 1587.* We here retain the traditional attribution to François Stella, though one may see in this drawing the work of the architect and draftsman Etienne Martellange (1569–1641) who accompanied Stella on his trip to Rome. Having become a monk, Martellange participated in the intense activity of the Jesuits in France in the early seventeenth century. [21]

31 Lodovico Cardi (called Cigoli; 1559–1613), *Narcissus,* Louvre Museum 67

Brush, brown wash, pen and brown ink, heightened in white over black chalk lines, on prepared green paper (28.4 × 39.3). There is nothing that would allow us to associate this drawing by Cigoli, one of the illustrators of the first Florentine Baroque, with any painted composition. However, the very colorful technique suggests a late date. [22]

32 Cigoli, *Study of Narcissus* (verso of 31), Louvre Museum 66

33 Sulpice Chevallier (called Gavarni; 1804–66), *Two Pierrots Looking into a Box,* Louvre Museum 71

Watercolor on brown paper (33.6 × 24.7). Inscribed and signed at lower right with brush: *Hommage respectueux à Madame Leroy. Gavarni.* An illustration by the prolific Gavarni, whose often biting paintbrush untiringly sketched the world of "lorettes" and carnival figures that were then made into series for Parisian magazines. The indiscreet gaze of *Two Pierrots Looking into a Box* was included in *The School of Pierrots,* a series relating the pranks of young comedians that was put together for the newspaper *Paris* around 1852. [23]

34 Jean-Baptiste Siméon Chardin (1699–1779), *Self-Portrait with Eyeshade,* Louvre Museum 74

Pastel on gray-blue paper (46.1 × 38.5). Signed and dated at lower right on two lines: *Chardin/1775. Self-Portrait with Eyeshade,* together with *Portrait of Madame Chardin,* its matching piece, and a third pastel, the identity of which remains anonymous, were very favorably received at the Salon of 1775. The Chicago Art Institute owns another version of these two portraits which are from a later date (1776) than the Louvre's version and in which the subjects are treated more freely. [16]

35 Jean-Baptiste Siméon Chardin, *Self-Portrait with Spectacles,* Louvre Museum 74

Pastel on gray-blue paper (46 × 37.5). Signed and dated at lower right on two lines: *Chardin/1771.* Quite probably one of the "three head studies in pastel" presented at the Salon of 1771. [18]

36 Jean-Baptiste Siméon Chardin, *Self-Portrait at the Easel,* Louvre Museum 75

Pastel on blue paper (40.5 × 32.5). Late self-portrait of the artist who, sensitive to the emanations of pigment, abandoned oil painting for the

less dangerous pastel. Chardin exhibited pastels at the Salon from 1771 to 1779. [17]

37 Félicien Rops (1833–98), *Woman with Monocle,* Louvre Museum, Orsay Museum Collection 76

Charcoal (58 × 41). Inscribed, signed, and monogrammed at upper left: *à mon ami Ernest Scaron/Félicien Rops/FR.* The *Woman with Monocle,* whose gaunt and gangrenous face echoes Baudelairian creations, is an early piece (produced around 1860) portraying the women of little virtue whom Rops, a famous illustrator from Brussels, rendered with his ferocious and provocative pencil. Rops' *Woman* was later disseminated on a wider scale by the engraving that Bertrand did of the piece in 1896. [24]

38 Pisanello, *Study of Three Heads,* Louvre Museum 77

39 Odilon Redon (1840–1916), *With Closed Eyes,* Louvre Museum, Orsay Museum Collection (gift of Arï and Suzanne Redon) 78

Red chalk on tan cardboard painted gray (49.5 × 37). Signed at lower right in black pencil: ODILON REDON. *With Closed Eyes* (1890) is one of the first drawings that Redon, until then a devotee of charcoal, transposed to painting (Orsay Museum). The success of the canvas was bolstered by a lithograph presented in 1894 at Durand-Ruel and by a pastel conserved in Epinal (regional museum of the Vosges). [28]

40 Bernard de Ryckere (ca. 1533–90), *Head of a Dying Man,* Louvre Museum 79

Black and red chalks, heightened with white (29.7 × 21.2). Monogrammed and dated at upper right in black chalk: *1563/B.* This head study, whose model is not known, was attributed because of the monogram to a *Master B.* The work of K.-J. Boon has only recently allowed an identification of this piece as the work of Bernard de Ryckere, a portraiturist and religious painter as well as an emulator of Frans Floris, who seems to have enjoyed a distinguished position among the notables of Anvers. [25]

41 German School (around 1540), *Portrait of Margarete Prellwitz,* Louvre Museum 79

Black chalk, brown and red washes, heightened with white (28.8 × 22.3). Inscribed on verso in pen and brown ink: HANS SCHENICZ MVOTTER and *Margreit Brelwiczin* AETATIS SUAE (the rest is hidden by the mounting; Behling sees the number 71). According to the annotations on the back of this mortuary portrait, the subject is Margarete Prellwitz, the mother of the secretary of Cardinal Albert of Brandenburg, elector of Mainz, Chancellor Hans Schönitz. The former attribution to Grünewald, which rested in part on the friendship that the painter shared with the notable from Augsburg, is not well founded, since at the time of Margarete Prellwitz's death in 1539, Grünewald had been dead for ten years. [26]

42 Francesco Vanni (1563–1610), *The Blessed Pasitea Crogi,* Louvre Museum 80

> Charcoal, red chalk, heightened with white and yellow pastel, on gray paper (19 × 14.7). A portrait of Pasitea Crogi at prayer. This nun from Sienna (who died in 1615) was famous in Florence for her mysticism and her powers of thaumaturgy. The drawing echoes the spiritual renewal of the Counter-Reformation, which Vanni championed by producing a number of edifying images at the request of the Sienna clergy. [27]

43 Gustave Courbet (1819–77), *Self-Portrait* (called *The Wounded Man*), Orsay Museum 81

> Oil on canvas (81 × 97). Signed at lower left: *G. Courbet* (apocryphal?). In 1854, Courbet, who produced a number of self-portraits, reworked a composition entitled *La Sieste Champêtre.* Originally composed more than ten years earlier, the painting depicted the artist and one of his woman companions, believed to be Virginie Binet, whose face he then suppressed, no doubt as a result of having been spurned by Binet. The sword and the blood stain that were added at that time completed the transformation of the work subsequently called *The Wounded Man.* [20]

44 Giacinto Calandrucci (1646–1707), *Head of Medusa,* Louvre Museum 82

> Red chalk (32.2 × 17). (On verso, in pen and brown and red chalks: *Moses and the Bearer of Grapes.*) The original intention of this drawing is not known (i.e., it is not known whether this is a simple study or copy of a finished composition). According to D. d'Ormesson Peugeot, although the piece is not characteristic of the artist, the recto, *Moses and the Bearer of Grapes,* is undoubtedly his work. [32]

45 Seventeenth-century Neapolitan School, reworked by Charles Natoire (1700–77), *Perseus Changing Phineus into Stone,* Louvre Museum 83

> Metal point, black chalk, brown and gray washes, pen and brown ink, heightened with gouache (31.9 × 47.5). Squared in red chalk with construction lines in red and black chalks. The drawing shows Perseus brandishing the head of Medusa, whose gaze petrifies (in the literal sense) Phineus, his rival for the love of Andromeda, whom he had delivered from the sea monster, thus obtaining her hand from King Cepheus. The drawing, thought in the past to be a copy after Solimena, was probably the property of Natoire, whose collection was in part acquired by the Count of Orsay after Natoire's death. It is known that Natoire had the habit of touching up the drawings in his collection. That he likewise embellished this Neapolitan drawing is a possibility that cannot be fully discounted. [33]

46 Carel Van Mander, *Perseus Changing Phineus into Stone,* Louvre Museum 84

47 Luca Giordano, *Perseus Beheading Medusa,* Louvre Museum 84

48 Odilon Redon, *The Eye with Poppy,* Louvre Museum, Orsay Museum
Collection (gift of Claude Roger-Marx) 85
> Charcoal on chamois paper (48.5 × 33). Signed at lower right: ODILON
> REDON. Executed in 1892. The theme of the eye seems to have fascinated
> Redon during the *Noirs* Period (1870–1890), in which the artist privi-
> leged the technique of charcoal. This piece suscitated the gloss of his
> contemporaries, who saw in it either the eye of uncertainty, the eye of
> conscience, or the eye of pain. [34]

49 Annibale Carracci (1560–1609), *Polyphemus,* Louvre Museum 86
> Black chalk, heightened with white, on gray-blue paper (52 × 38.7).
> Inscribed at bottom in pen and brown ink: *Figure de Poliphème et de
> Galattée,* and at lower right: *27.* A study in detail of the cyclops Polyphe-
> mus in the lunette depicting *Polyphemus Loving the Nymph Galatea,* a
> fresco painted on one of the smaller sides of the Farnese Gallery in Rome,
> one of the major cycles (1597–1603) of the artist. [30]

50 Francesco Primaticcio, *Vulcan's Workshop,* Louvre Museum 90
> Red chalk, red wash; contours in pen and black ink (31.3 × 41.8). On
> verso, paraphs of Jabach and Prioult (the examiner-curator at Châtelet in
> charge of verifying the drawings that came into the Cabinet of the King
> under Louis XIV). A study for the decoration of the chimney of the
> King's Chamber in Fontainebleau. The study presents the theme of Vul-
> can, the god of metallurgy, who forges weapons for the gods with the
> help of his workers, the cyclopes. As successor to Rosso (after 1540) in
> the direction of the royal building sites, Primaticcio realized this study
> around 1541–45. The chimney was destroyed in 1713. [31]

51 After Giulio Romano, *Fall of the Giants,* Louvre Museum 90

52 Louis de Boullogne le Jeune (1664–1733), *Cyclops,* Louvre Museum
91
> Black chalk, heightened with white, on blue paper (30.5 × 21.4). Mono-
> grammed at lower left in black chalk: *L.B.* A study in detail for *Venus
> Asking Weapons for Aeneas* or *The Fire,* this is one of the compositions
> given by Boullogne, then at the height of his career, to the engraver Louis
> Desplaces for a series of engraved plates on the subject of the Four Ele-
> ments (1717). The drawing at the Louvre can also be associated with
> Boullogne's painting of the same subject for the Menagerie of Versailles,
> a painting that was lost but is known through a drawing kept in a private
> collection in Paris. [29]

53 Jean-Marie Faverjon (1828–73), *Self-Portrait in Trompe l'œil,* Orsay
Museum 93
> Pastel (56.5 × 46.5). A student of Flandrin at the Ecole des Beaux-Arts,
> Jean-Marie Faverjon, whose little-known work touches upon all genres,
> was also a master of pastels, examples of which he began exhibiting at

can be dated close to 1559, the year in which Orsi—the tireless decorator of the churches of Emilia—had a copy of Michaelangelo's Vatican (Paolina chapel) work on the same subject sent to him. A *Conversion of Saint Paul* by Orsi is cited in the Coccapani and Campori collections. [42]

67 Laurent de La Hyre (1606–56), *The Conversion of Saint Paul,* Louvre Museum 114

Black chalk, gray wash, squared (36.9 × 40.7). *The Conversion of Saint Paul* is one of the seventeen drawings delivered around 1646 by La Hyre—who was considered to be one of the leading Parisian painters—to the Church of Saint-Etienne-du-Mont. The drawings were to serve as models for a tapestry depicting the life of Saint Stephen, whose lapidation Saul had approved. The tapestry, which was perhaps not completed because of the troubles of the Fronde, disappeared during the Revolution. [41]

68 Caravaggio, *The Conversion of Saint Paul,* Rome, Santa Maria del Popolo 115

69 Jan Provost (ca. 1470–1529), *Sacred Allegory,* Louvre Museum 120

Oil on wood (50.5 × 40). The provider of funds for this composition, which is unique among its kind in Provost's work and can be linked stylistically to the period 1510–20, is unknown. Its iconography, rich in symbols that are sometimes obscure, no doubt refers to the *Apocalypse,* although without illustrating any specific passage. Christ armed with a sword is likely an allusion to the Last Judgment, and the feminine figure likely represents the New Jerusalem. The eyes are more difficult to explain: the eye above perhaps represents Wisdom, while the half-closed eye, from which emerges a pair of hands, perhaps stands as a symbol of the human soul turned toward its creator. This painting, whose theological content still remains mysterious, was perhaps part of a Chamber of Rhetoric whose use was widespread in Flanders in the sixteenth century. [36]

70 Charles Le Brun (1619–90), *Weeping,* Louvre Museum 124

Pen and brown ink on a sketch in black chalk (19.5 × 25.9). Inscribed at upper left: *T,* and at bottom in the middle: *no. 32.* At bottom left, paraphs of J. Prioult (see no. 50). Inscribed on verso in upper left: *10 454,* and in upper middle: *T* and *Le pleurer.* Part of a copy album. This drawing illustrates one of the various states of the soul described by Le Brun in his famous conference on the *Expression of the Passions.* Presented at the Academy in 1668, the conference was intended to fix the rules of representation for historical painting. Published for the first time in 1698, the conference was reissued many times during the eighteenth century. The best-known edition, after which the album at the Louvre seems to have been fashioned, was that of Jean Audran (*Expression des Passions de l'âme représentées en plusieurs testes gravées d'après les dessins de feu Monsieur Le Brun;* Paris, 1727). [43]

71 Daniele Ricciarelli (called Daniele da Volterra; 1509–66), *Woman at the Foot of the Cross,* Louvre Museum 125

Red chalk (36.2 × 33.5). A study in detail for the *Deposition from the Cross,* this is the only fresco left from the decorations of the Orsini Chapel in the Church of Trinity-of-the-Mount in Rome (ca. 1545), and it is this study that caused its author to be considered one of the most promising painters of his generation. [44]